"Having stumbled _____ ___. __.__ capsule in a Paris storage room, Clara Beaudoux tweeted the contents to the world. Her texts and intriguing photos of artifacts were then melded to create a unique and engaging biography." —Charles Kaiser, author of
The Cost of Courage and *1968 in America*

"This book first delights the brain, then takes over the heart. Tweets turn into literature right before our eyes. As the posts and meticulous photos unfold, the writer deepens her own identity, even as the dead Madeleine emerges in all her eccentric humanity."
—Elizabeth Kendall, author of
Autobiography of a Wardrobe and *American Daughter*

"Brings the past into the present in a wildly creative and imaginative way. This story is truly special and will stay with you long after you put the book down." —Samantha Vérant, author of
Seven Letters from Paris and *How to Make A French Family*

"Simply magical … Words and images, magnified in this book, are woven together in small strokes to create two moving portraits of women." —*Lire*

"A beautiful book that bears witness. An original compilation of traces, thoughts and photos … that form the strata of our collective memory." —*Télérama*

"A strange but staggering experience." —*Le Figaro littéraire*

"A hymn to recovered memory." —*Elle*

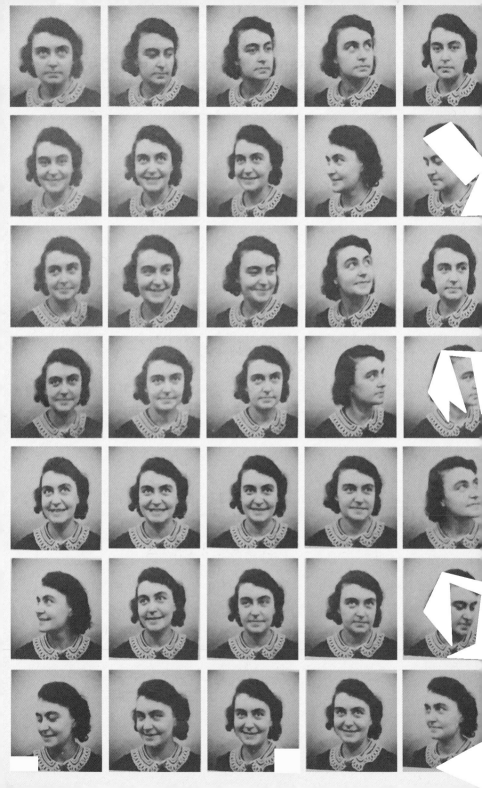

THE
MADELEINE
PROJECT

Uncovering a Parisian Life

CLARA BEAUDOUX

TRANSLATED BY ALISON ANDERSON

NEW VESSEL PRESS
NEW YORK

New Vessel Press

www.newvesselpress.com

First published in French in 2016 as Madeleine Project

Copyright © Editions du Seuil sous la marque des editions du Sous-sol, 2016

Ceci est une adaptation du hashtag Madeleine Project publié
sur le compte Twitter de Clara Beaudoux

This is an adaptation of hashtag Madeleine Project published
on the Twitter account of Clara Beaudoux

Translation Copyright © 2017 Alison Anderson

Reproduction of Tweets © Twitter

Library of Congress Cataloging-in-Publication Data
Beaudoux, Clara
[Madeleine Project. English]
The Madeleine Project/ Clara Beaudoux; translation by Alison Anderson.
p. cm.
ISBN 978-1-939931-49-8
Library of Congress Control Number 2017931356

France – Nonfiction

THE MADELEINE PROJECT

Her name was Madeleine

HER NAME WAS MADELEINE, and she would have been one hundred years old in 2015. My name is Clara, and I'm thirty-one. We never knew one another, and yet we are sharing the same apartment, or at any rate have shared it, although at different times. Madeleine lived there for twenty years. She died one year before I moved in, and in the meantime the apartment had been completely renovated. The cellar storage room that came with the apartment had been left in its original state, an interstice preserved from oblivion. Once I'd sawn through the padlock I could see it had been left very tidy, with everything packed away in cardboard boxes—Madeleine's life, objects, photographs, letters. For several days last November I immersed myself in it all, and I decided to make an inventory of storage room No. 16 over Twitter, to lose myself in this fascinating puzzle of memories, to migrate from little boxes to suitcases full of documents, to allow her life and mine to mingle for a brief period. Over two "seasons," thousands of Twitter followers were drawn to my reporting as I recorded, in missives of 140 characters or less, the material that has now been drawn together in this book. I was in search not of lost time but of a time

that had been lived, of fragments of memory marked by History. Was the purpose to combat forgetting? And furthermore, why insist on printing all these tweets, committing the immaterial to paper? Was it to preserve the memory of your memory, Madeleine? To keep a trace? But what will remain of the two of us? For over two years I've been wanting to tell this story. So now I will try to do it, here.

SEASON
1

clara beaudoux
@clarabdx

For two years I've been wanting to tell
this story. So I'll try to do it here, this week.

RETWEETS J'AIME
11 31

11:28 - 2 nov. 2015

clara beaudoux
@clarabdx

When I rented my apartment, I was pleasantly
surprised to find there was a cellar, but the
owner didn't know what was in there.

RETWEETS J'AIME
7 9

11:28 - 2 nov. 2015

It was cellar no. 16. He didn't have the key, either. I had to saw through the padlock.

The cellar was full of stuff that had belonged to the old lady who had lived for twenty years in this apartment and died here.

clara beaudoux
@clarabdx

In the mailbox I found some junk mail addressed
to her from an insurance company: her name
was Madeleine. #Madeleineproject

RETWEETS J'AIME
6 9

11:30 - 2 nov. 2015

clara beaudoux
@clarabdx

She had no heirs, so I called her only contact,
according to the owner: her godson.

RETWEETS J'AIME
2 2

11:32 - 2 nov. 2015

clara beaudoux
@clarabdx

Over the phone he told me he had hired
a company to empty the apartment, but
apparently they forgot about the cellar.

11

RETWEETS J'AIME
3 3

11:32 - 2 nov. 2015

clara beaudoux
@clarabdx

He's not interested in his godmother's things; he
said I can do what I want with them.

RETWEETS J'AIME
2 3

11:33 - 2 nov. 2015

clara beaudoux
@clarabdx

So I have a cellar full of Madeleine's
things. Which no one wants. I'm going
to sort through them to try to find out more
about her.

RETWEETS J'AIME
6 5

11:34 - 2 nov. 2015

clara beaudoux
@clarabdx

I could see right away that Madeleine
seemed to be well organized. She kept
back issues of Historia.

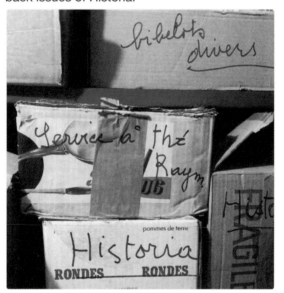

RETWEETS J'AIME
3 5

11:36 - 2 nov. 2015

clara beaudoux
@clarabdx

Madeleine kept all her Christmas ornaments in this Styrofoam box.

RETWEETS J'AIME
2 1

11:38 - 2 nov. 2015

clara beaudoux
@clarabdx

Was Madeleine hiding a Picasso?

13

RETWEETS J'AIME
2 2

11:40 - 2 nov. 2015

clara beaudoux
@clarabdx

Afraid not. #Madeleineproject

RETWEETS J'AIME
2 4

11:42 - 2 nov. 2015

clara beaudoux
@clarabdx

I found some very weird things during
my initial sorting, and they went straight
into the garbage.

RETWEETS J'AIME
4 1

11:45 - 2 nov. 2015

clara beaudoux
@clarabdx

It looks like the most precious treasures are the suitcases filled with Madeleine's life.
#Madeleineproject

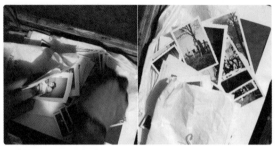

RETWEETS J'AIME
10 13

11:52 - 2 nov. 2015

DAY 1

clara beaudoux
@clarabdx

There's this box full of little objects, the kind of things you might really care about
#Madeleineproject

15

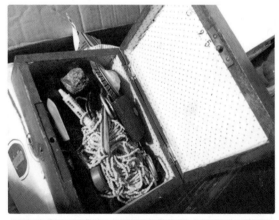

RETWEETS J'AIME
3 12

11:57 - 2 nov. 2015

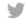

clara beaudoux
@clarabdx

There's this very tiny leather case, and inside it... ? #Madeleineproject

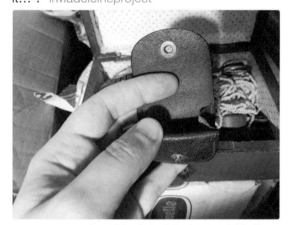

RETWEETS J'AIME
2 6

11:58 - 2 nov. 2015

clara beaudoux
@clarabdx

Inside there is a pendant with a baby tooth!
#Madeleineproject

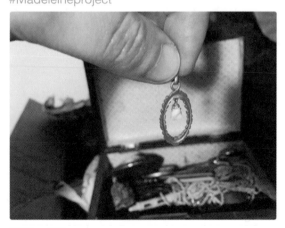

RETWEETS J'AIME
10 38

12:02 - 2 nov. 2015

 clara beaudoux
@clarabdx

And at the same time I learned about this custom… etsy.com/fr/shop/TinyTo…
#previoustweet

RETWEET
1

12:03 - 2 nov. 2015

clara beaudoux
@clarabdx

In the same little case there is a tiny faded photograph #Madeleineproject

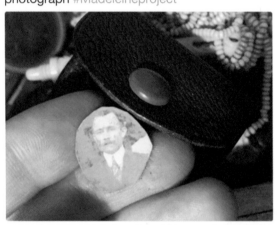

RETWEETS J'AIME
7 4

12:20 - 2 nov. 2015

DAY 1

17

clara beaudoux
@clarabdx

I wonder what this little gadget is for
#Madeleineproject

RETWEETS JAIME
12 6

12:32 - 2 nov. 2015

clara beaudoux
@clarabdx

Note to myself for later: the network coverage
is lousy in the cellar #Madeleineproject

RETWEET JAIME
1 4

12:46 - 2 nov. 2015

That painting I found earlier – maybe Madeleine painted it, in any case she had the materials #Madeleineproject

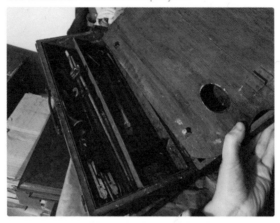

RETWEET J'AIME
1 6

12:48 - 2 nov. 2015

Another pretty little box, this one's cardboard, I wonder what's inside? #Madeleineproject

RETWEET J'AIME
1 4

12:54 - 2 nov. 2015

What do you know, little stickers, all stars
<3

RETWEETS J'AIME
2 8

12:56 - 2 nov. 2015

Stationery supplies, school notebooks,
this might shed some light on Madeleine's
profession...

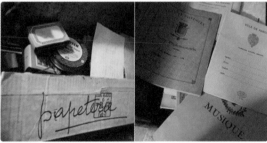

RETWEETS J'AIME
4 10

12:58 - 2 nov. 2015

clara beaudoux
@clarabdx

I think Madeleine must have inherited
her parents' things too, like these coal
coupons

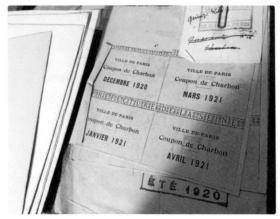

RETWEETS J'AIME
4 10

13:02 - 2 nov. 2015

clara beaudoux
@clarabdx

One suitcase full of photographs, groups or
classes, the same person in each of them.
#Madeleineproject

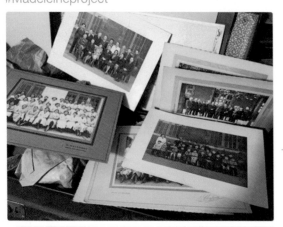

RETWEETS J'AIME
3 15

13:06 - 2 nov. 2015

clara beaudoux
@clarabdx

On the back of one of them it says "me,"
"Aubervilliers – Jean Macé," it's a school group,
"1944-1945"

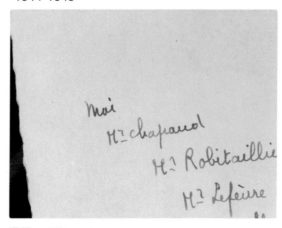

RETWEET J'AIME
1 4

13:09 - 2 nov. 2015

clara beaudoux
@clarabdx

So I think this must be Madeleine in these
photographs #Madeleineproject

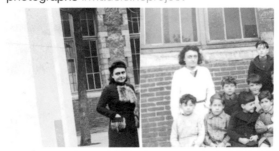

RETWEETS J'AIME
8 14

13:11 - 2 nov. 2015

Still so much to explore among
Madeleine's fossils, more tomorrow!
#Madeleineproject

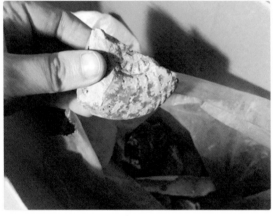

RETWEETS J'AIME
2 10

13:15 - 2 nov. 2015

DAY 1

clara beaudoux
@clarabdx

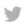

This morning I'm going to go on rummaging
in all these suitcases filled with Madeleine's life
#Madeleineproject

25

RETWEETS J'AIME
7 13

10:47 - 3 nov. 2015

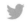

clara beaudoux
@clarabdx

Madeleine had an entire collection of little "If you love Paris" posters
#Madeleineproject

RETWEETS J'AIME
4 14

10:50 - 3 nov. 2015

clara beaudoux
@clarabdx

She loved Holland, and must have had ties there, an entire little briefcase filled with guidebooks

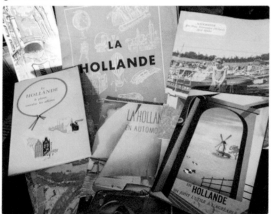

J'AIME
11

10:51 - 3 nov. 2015

And here's another unfamiliar object: any ideas? #Madeleineproject (cc @SanzzoCreatrice who found yesterday's)

RETWEET 1 J'AIME 8

10:55 - 3 nov. 2015

clara beaudoux
@clarabdx

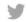

In the suitcases there is some edifying reading material #Madeleineproject

RETWEETS 3 J'AIME 12

[Housekeeping/ Home Economics]

10:56 - 3 nov. 2015

clara beaudoux
@clarabdx

Il y a aussi un gros tas de cartes postales
There is also a huge pile of postcards
#Madeleineproject

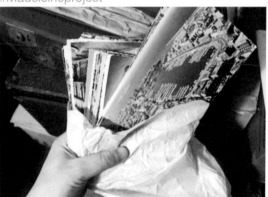

RETWEET 1 J'AIME 5

10:57 - 3 nov. 2015

clara beaudoux
@clarabdx

A lot of these cards were actually written
BY Madeleine, in the 60s and 70s, many of
them from Provence

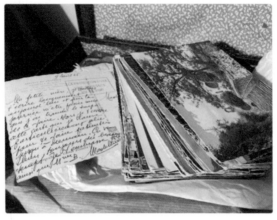

RETWEETS | J'AIME
2 | 11

11:02 - 3 nov. 2015

clara beaudoux
@clarabdx

In fact she's writing to her mother, who lives
in Seine-et-Marne, and each card starts off "My
dear little mother"

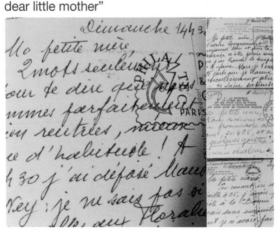

RETWEETS | J'AIME
5 | 13

11:07 - 3 nov. 2015

clara beaudoux
@clarabdx

Several cards are also addressed to
"Madame and Mademoiselle Madeleine,"
all from 1964 or 1965

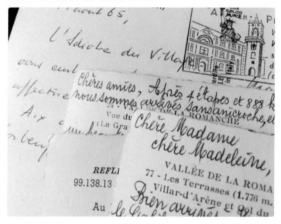

J'AIME
5

11:28 - 3 nov. 2015

clara beaudoux
@clarabdx

I think back then you lived with your
mother, in Seine-et-Marne; one card
refers to some illness

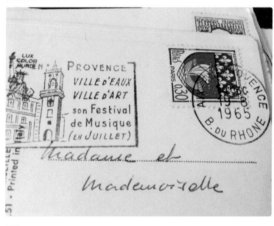

J'AIME
7

11:29 - 3 nov. 2015

clara beaudoux
@clarabdx

To ease the tension, a little recipe found at random in a notebook #Madeleineproject

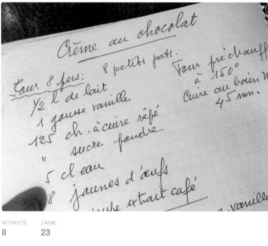

RETWEETS 8 J'AIME 23

11:33 - 3 nov. 2015

DAY 2

clara beaudoux
@clarabdx

Madeleine liked keeping her little things in little boxes or pouches
#Madeleineproject

RETWEET 1 J'AIME 9

11:39 - 3 nov. 2015

 clara beaudoux
@clarabdx

And you never know what to expect.
This time I found two coins, and then…
#Madeleineproject

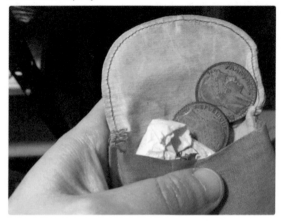

J'AIME
6

11:42 - 3 nov. 2015

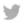 **clara beaudoux**
@clarabdx

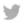

And then… #Madeleineproject #suspense

J'AIME
4

11:45 - 3 nov. 2015

clara beaudoux
@clarabdx

Ta-da: another tooth story… But I don't
quite know what it is #Madeleineproject

J'AIME
6

11:47 - 3 nov. 2015

 clara beaudoux
@clarabdx

There are vast quantities of photographs
in these suitcases, I'm a bit overwhelmed,
is this Madeleine? #Madeleineproject

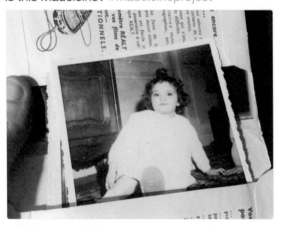

RETWEETS J'AIME
2 12

11:53 - 3 nov. 2015

I think this must be her, a fine series of portraits
#Madeleineproject

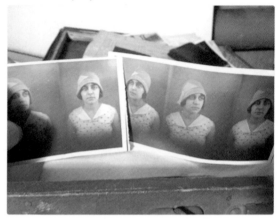

RETWEETS 8 J'AIME 23

11:55 - 3 nov. 2015

 clara beaudoux
@clarabdx

This suitcase is organized by envelope,
one for each individual, one for each
story #Madeleineproject

RETWEET 1 J'AIME 6

12:00 - 3 nov. 2015

clara beaudoux
@clarabdx

It looks like Madeleine kept her family history in this one, here's a marriage certificate from 1863 #Madeleineproject

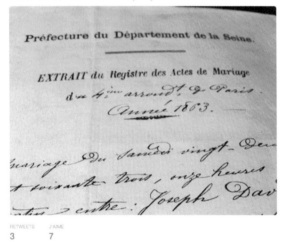

Préfecture du Département de la Seine.

EXTRAIT du Registre des Actes de Mariage

d.. 4ᵉ arrond.ᵗ de Paris.

Année 1863.

mariage Du samedi vingt-Deu
+ soixante trois, onze heures
... entre : Joseph Dav

RETWEETS J'AIME
3 7

12:05 - 3 nov. 2015

clara beaudoux
@clarabdx

In the envelope marked "Adrien" there is this teeny tiny little calendar from 1918 #Madeleineproject

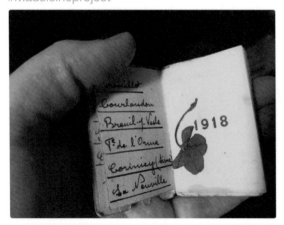

RETWEET J'AIME
1 13

12:09 - 3 nov. 2015

 clara beaudoux
@clarabdx

In the "Martial" envelope (her brother?) there is
his dog tag from the army, his driver's license,
and a letter… #Madeleineproject

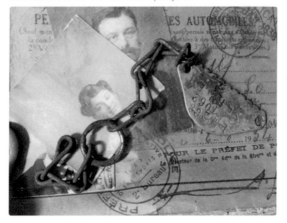

RETWEETS J'AIME
5 8

12:14 - 3 nov. 2015

 clara beaudoux
@clarabdx

…informing his mother of his death,
"your poor son Martial," "fallen in glory"
#Madeleineproject

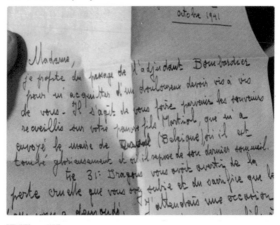

RETWEETS J'AIME
6 23

12:16 - 3 nov. 2015

clara beaudoux
@clarabdx

There is a lot about the war, I'll come back
to it later #Madeleineproject

J'AIME
1

12:38 - 3 nov. 2015

clara beaudoux
@clarabdx

A little notebook with a drawing of a strange
little man, a priest? I thought you'd draw better
than that :) #Madeleineproject

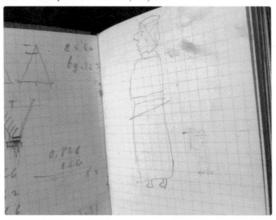

J'AIME
3

12:40 - 3 nov. 2015

clara beaudoux
@clarabdx

An envelope that hasn't even been opened,
"French National Railroad Company,"
tucked in there #Madeleineproject

J'AIME
3

12:44 - 3 nov. 2015

clara beaudoux
@clarabdx

I take the liberty of opening it... Again,
someone's entire life inside #Madeleineproject

J'AIME
6

12:45 - 3 nov. 2015

And guess what this is?

#Madeleineproject

J'AIME
4

39

12:46 - 3 nov. 2015

clara beaudoux
@clarabdx

Yes you got it @RodolpheCaribou it's
Madeleine's diplomas! I counted them,
there are seven in all! #Madeleineproject

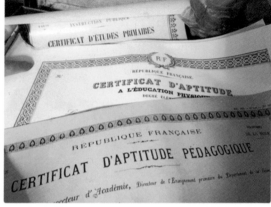

RETWEET J'AIME
1 10

12:53 - 3 nov. 2015

clara beaudoux
@clarabdx

Diplomas that give us precious information
about Madeleine... #Madeleineproject

J'AIME
2

12:58 - 3 nov. 2015

clara beaudoux
@clarabdx

"Born in March 1915": Madeleine would be one hundred years old! #Madeleineproject

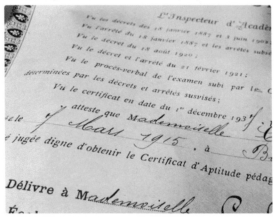

RETWEETS J'AIME
3 19

13:00 - 3 nov. 2015

clara beaudoux
@clarabdx

And I'll end for today with this notebook where Madeleine copied out song lyrics #Madeleineproject

RETWEETS J'AIME
2 11

13:03 - 3 nov. 2015

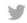

clara beaudoux
@clarabdx

In particular the lyrics to "Garde ton coeur
Madeleine" #Madeleineproject

J'AIME
8

13:06 - 3 nov. 2015

clara beaudoux
@clarabdx

Which you can listen to here, I think:
deezer.com/track/232916 #Madeleineproject

 Garde ton coeur Madeleine
Carvey
deezer.com

J'AIME
12

13:06 - 3 nov. 2015

 clara beaudoux
@clarabdx

I'll leave you with the other soundtrack for
this project: youtube.com/watch?v=TElHls…
And see you tomorrow for more
#Madeleineproject

 Brel Madeleine
Brel on stage 1966
youtube.com

RETWEET J'AIME
1 8

13:07 - 3 nov. 2015

 clara beaudoux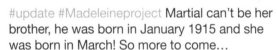
@clarabdx

#update #Madeleineproject Martial can't be her
brother, he was born in January 1915 and she
was born in March! So more to come…

RETWEET J'AIME
1 7

13:45 - 3 nov. 2015

 clara beaudoux
@clarabdx

Let's leave the suitcases this morning (we'll get back to them) and explore the boxes and lampshades #Madeleineproject

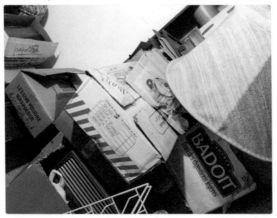

RETWEETS J'AIME
3 3

11:06 - 4 nov. 2015

clara beaudoux
@clarabdx

Here's a puzzle: what's in this big box?
#Madeleineproject

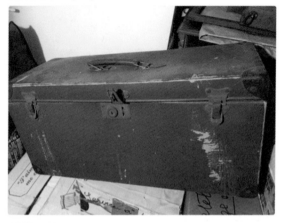

RETWEETS J'AIME
3 5

11:10 - 4 nov. 2015

clara beaudoux
@clarabdx

Neither clothes, nor an instrument, but…
ice skates! #Madeleineproject

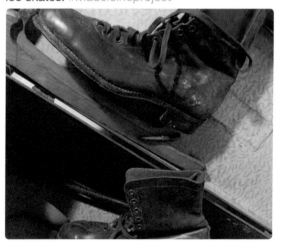

RETWEETS J'AIME
3 20

11:16 - 4 nov. 2015

clara beaudoux
@clarabdx

(I love the skating rink, too, Madeleine)

RETWEET J'AIME
1 6

11:16 - 4 nov. 2015

clara beaudoux
@clarabdx

Madeleine wore a size 36 shoe. Someone on Twitter said "we're taking tiny steps into her life" #Madeleineproject

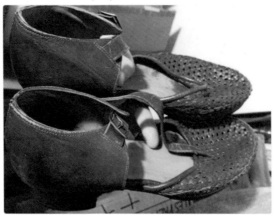

J'AIME
16

11:19 - 4 nov. 2015

clara beaudoux
@clarabdx

You never wore these ones, who gave
them to you? Besides, they're too big,
size 38 #Madeleineproject

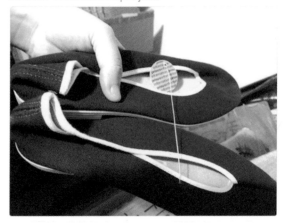

J'AIME
7

11:21 - 4 nov. 2015

clara beaudoux
@clarabdx

A box full of knickknacks, ugly stuff, you
must have thought so too if you left them down
here #Madeleineproject

J'AIME
5

11:25 - 4 nov. 2015

clara beaudoux
@clarabdx

The knickknacks were wrapped up in newspaper from 1994, with Prime Minister Balladur and Paris Mayor Tiberi #Madeleineproject

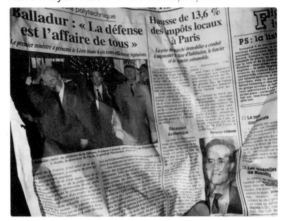

J'AIME
5

11:28 - 4 nov. 2015

clara beaudoux
@clarabdx

It looks like you read Le Figaro, Madeleine #Madeleineproject

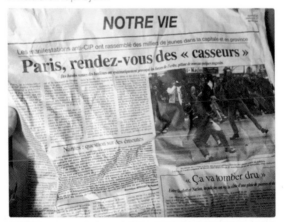

RETWEETS J'AIME
2 7

11:31 - 4 nov. 2015

clara beaudoux
@clarabdx

Then there's this tea set that belonged to Raymonde. Who was Raymonde?
#Madeleineproject

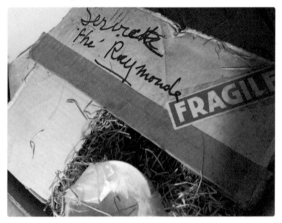

RETWEETS 2 J'AIME 10

11:33 - 4 nov. 2015

clara beaudoux
@clarabdx

Madeleine also had a first-class tennis racket, ever so hard to get it back into its case #Madeleineproject

RETWEETS 2 J'AIME 10

11:35 - 4 nov. 2015

clara beaudoux
@clarabdx

There's a box with household linens, they're a bit mildewed now, and this pretty kitchen towel from 1969 #Madeleineproject

J'AIME
8

11:38 - 4 nov. 2015

clara beaudoux
@clarabdx

51

In the middle of the bedsheets, it probably ended up there by chance, there's this document about a trip to Finland #Madeleineproject

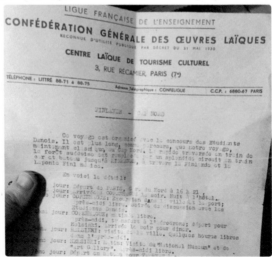

RETWEET J'AIME
1 9

11:41 - 4 nov. 2015

 clara beaudoux
@clarabdx

There's no year, it was from July 9 to August 2,
and the document lists in detail what you did every
day. You were quite a traveler #Madeleineproject

J'AIME
4

11:45 - 4 nov. 2015

 clara beaudoux
@clarabdx

Yes, Madeleine really did collect Historia
magazine #Madeleineproject

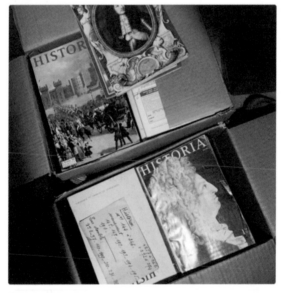

J'AIME
12

11:50 - 4 nov. 2015

clara beaudoux
@clarabdx

But there were issues missing: 145, 147,
192, 193, 194, 195, 196 #Madeleineproject

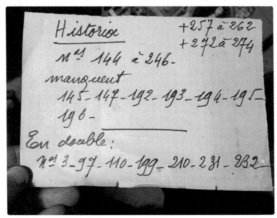

J'AIME
17

11:51 - 4 nov. 2015

clara beaudoux
@clarabdx

There are also boxes full of books in the
cellar, like this one about mushrooms
#Madeleineproject

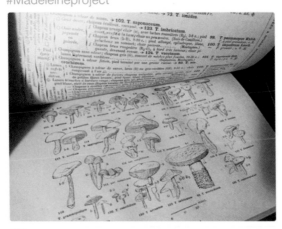

J'AIME
9

11:58 - 4 nov. 2015

clara beaudoux
@clarabdx

And a very pretty book about Bourges,
Madeleine was born in Bourges (so it said
on her diplomas) #Madeleineproject

RETWEETS J'AIME
6 11

11:59 - 4 nov. 2015

 clara beaudoux
@clarabdx

The diplomas also tell us her first and
middle names were "Madeleine, Julia, Jeanne,
Georgette" #Madeleineproject

J'AIME
7

12:00 - 4 nov. 2015

 clara beaudoux
@clarabdx

And there's this book: "Authentic Family Cooking," which must have come down through the generations... #Madeleineproject

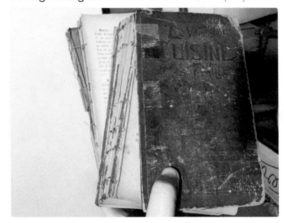

RETWEETS 2 J'AIME 14

12:02 - 4 nov. 2015

 clara beaudoux
@clarabdx

There are postcards from the "National League Against Slums" (liguenationalecontreletaudis.fr) #Madeleineproject

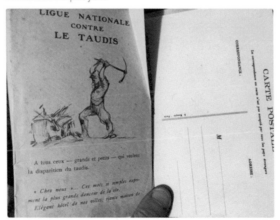

RETWEETS 6 J'AIME 7

12:08 - 4 nov. 2015

With cards that are supposed to be rather humorous, apparently to condemn living conditions #Madeleineproject

JAIME
14

["Leave him alone, he's not used to it yet, it's the fleas that are keeping him from sleeping."]

12:08 - 4 nov. 2015

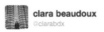 **clara beaudoux**
@clarabdx

There are loads of children's books, from different eras #Madeleineproject

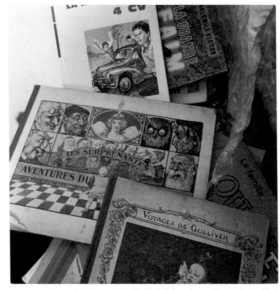

RETWEETS 3 J'AIME 22

57

12:11 - 4 nov. 2015

clara beaudoux
@clarabdx

Then all of a sudden, in the middle of all `
these books, on one side of the box, look who's
here… #Madeleineproject

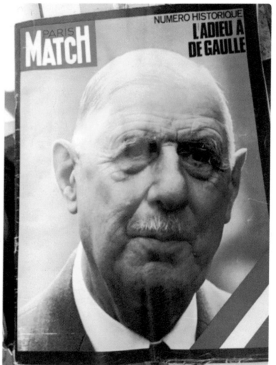

RETWEETS J'AIME
14 14

12:12 - 4 nov. 2015

clara beaudoux
@clarabdx

I found this paper on the floor, it must have fallen from a book. It's one of Madeleine's shopping lists! #Madeleineproject

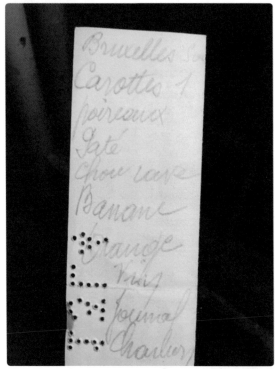

J'AIME
17

[Brussels sprouts, Carrots and leeks, Kohlrabi, Banana, Orange, Wine, Newspaper, etc.]

12:20 - 4 nov. 2015

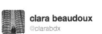

clara beaudoux
@clarabdx

A shopping list written on the back of a wrapper
for low-calorie crackers #Madeleineproject

RETWEET J'AIME
1 8

12:25 - 4 nov. 2015

clara beaudoux
@clarabdx

Ah, some more Historia magazines in this one!
#Madeleineproject

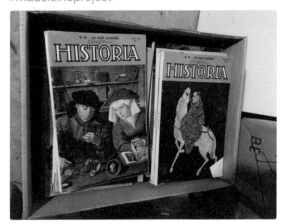

RETWEET J'AIME
1 5

12:30 - 4 nov. 2015

clara beaudoux
@clarabdx

But they're in a box where on the top it says, "knickknacks." This is surprising, coming from you, Madeleine #Madeleineproject

RETWEET J'AIME
1 4

12:31 - 4 nov. 2015

clara beaudoux
@clarabdx

Look, the lyrics to "Jeanneton," not quite the same as the ones I learned at summer camp #Madeleineproject

RETWEETS J'AIME
7 21

["Little Jeannie"]

12:36 - 4 nov. 2015

clara beaudoux
@clarabdx

There's one box that stands out, full of brand new napkins, almost as if they had "fallen off the back of the truck" :) #Madeleineproject

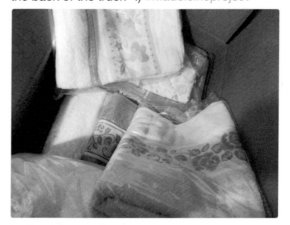

RETWEETS J'AIME
3 15

12:41 - 4 nov. 2015

clara beaudoux
@clarabdx

Fortunately I had another look in the "stationery" box, the one with the crêpe paper and labels #Madeleineproject

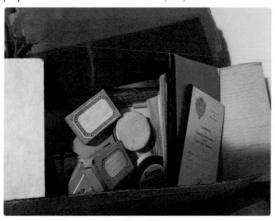

J'AIME
14

12:44 - 4 nov. 2015

clara beaudoux
@clarabdx

In it I found this little notebook, you have a few
of them, not unlike my own little Moleskines
#Madeleineproject

J'AIME
10

12:46 - 4 nov. 2015

DAY 3

clara beaudoux
@clarabdx

63

And in it you describe your trip to
Holland, Madeleine! Almost by the hour
#Madeleineproject

RETWEETS J'AIME
3 11

12:52 - 4 nov. 2015

clara beaudoux
@clarabdx

Don't all grandmothers have the same handwriting? #Madeleineproject

RETWEETS 9 J'AIME 71

12:53 - 4 nov. 2015

clara beaudoux
@clarabdx

"Noon: Willy starts filming." Who's Willy? Did he film you, Madeleine? In Holland? #Madeleineproject

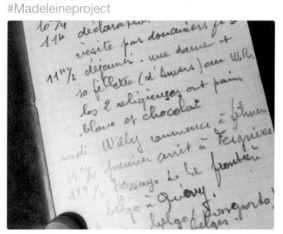

RETWEETS 3 J'AIME 9

12:58 - 4 nov. 2015

clara beaudoux
@clarabdx

You describe your trip from August 14 to
September 8, 1947, the date when "Jacques"
came to meet you at the station #Madeleineproject

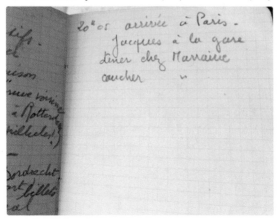

J'AIME
10

13:04 - 4 nov. 2015

clara beaudoux
@clarabdx

But right in the middle of the pages about
the trip there's a little digression, pages
about "gardening" #Madeleineproject

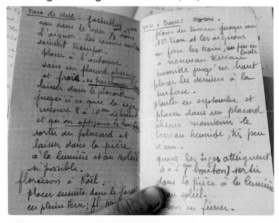

RETWEETS J'AIME
2 9

13:08 - 4 nov. 2015

clara beaudoux
@clarabdx

You write down the best way to plant hyacinths and crocuses, you even try to make it easier with little drawings #Madeleineproject

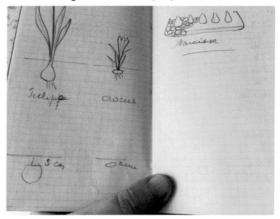

RETWEETS J'AIME
4 18

13:10 - 4 nov. 2015

clara beaudoux
@clarabdx

(I'm hopeless at gardening, Madeleine)

J'AIME
5

13:10 - 4 nov. 2015

clara beaudoux
@clarabdx

Is this Dutch?

#Madeleineproject

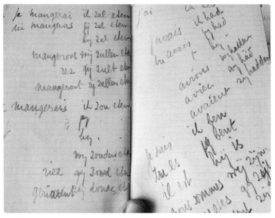

RETWEETS 2 J'AIME 6

13:15 - 4 nov. 2015

clara beaudoux
@clarabdx

In the stationery box there is also a list with all your trips. It's as if you're leaving me clues

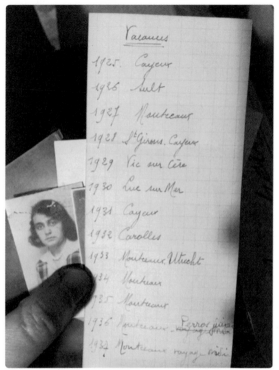

RETWEETS J'AIME
6 31

13:17 - 4 nov. 2015

clara beaudoux
@clarabdx

And then in the stationery box, under
the little boxes, in another pretty box…
#Madeleineproject

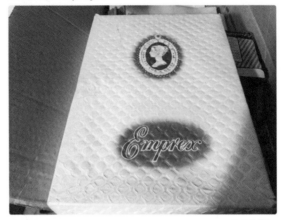

J'AIME
5

13:18 - 4 nov. 2015

DAY 3

clara beaudoux
@clarabdx

Oh, Madeleine! It's full of pencils!
#Madeleineproject

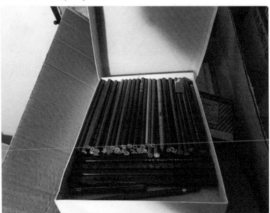

RETWEETS J'AIME
2 22

13:20 - 4 nov. 2015

clara beaudoux
@clarabdx

And the sound of your pencils in the silence of the cellar #Madeleineproject

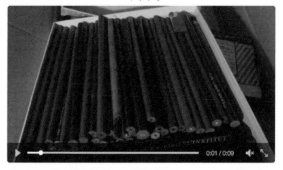

0:01 / 0:09

RETWEETS J'AIME
6 43

13:23 - 4 nov. 2015

clara beaudoux
@clarabdx

That's enough for today, tomorrow we'll start on this suitcase #Madeleineproject

RETWEETS J'AIME
2 15

13:24 - 4 nov. 2015

clara beaudoux
@clarabdx

Packed with forgotten history inside
History, or could it be the other way around
#Madeleineproject See you tomorrow!

RETWEETS J'AIME
5 25

13:25 - 4 nov. 2015

DAY 3

 clara beaudoux
@clarabdx

 73

For newcomers, here's a summary of the
previous episodes: storify.com/clarabdx/madel…
#Madeleineproject

 #Madeleineproject SAISON 1 (with images, tweets) · clarabdx
A Social Media Story storified by clarabdx
storify.com

RETWEETS J'AIME
8 10

10:40 - 5 nov. 2015

 clara beaudoux
@clarabdx

For the rest of you, a little #update to start with
about the box of linens "that fell off the back of
the truck" #Madeleineproject

10:42 - 5 nov. 2015

clara beaudoux
@clarabdx

In fact on the box it said "gift linens," but I didn't see it, so now it makes more sense
#Madeleineproject

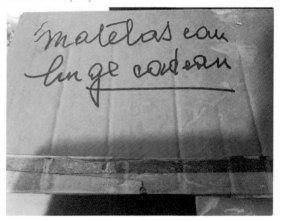

RETWEET 1 J'AIME 5

10:45 - 5 nov. 2015

clara beaudoux
@clarabdx

A few little things before the big suitcase. Madeleine had a lot of books
#Madeleineproject

RETWEET 1 J'AIME 8

10:47 - 5 nov. 2015

clara beaudoux
@clarabdx

This one in particular… "Croix-du-Sud ne répond plus"—The White South in English—by Hammond Innes #Madeleineproject

J'AIME
3

10:50 - 5 nov. 2015

clara beaudoux
@clarabdx

And you forgot to return it to the library, Madeleine! #Madeleineproject

RETWEET J'AIME
1 14

10:51 - 5 nov. 2015

clara beaudoux
@clarabdx

There was also "La Terre"—"The Earth"—
by Zola, I have the same edition on my
bookshelf #Madeleineproject

RETWEETS J'AIME
2 11

10:53 - 5 nov. 2015

clara beaudoux
@clarabdx

And your textbooks #Madeleineproject

RETWEETS J'AIME
2 11

10:56 - 5 nov. 2015

clara beaudoux
@clarabdx

A strange way to physically connect with the project, Madeleine :) #Madeleineproject

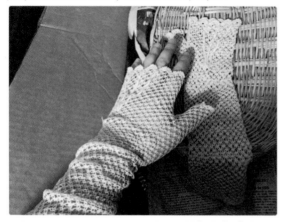

RETWEET J'AIME
1 25

10:59 - 5 nov. 2015

clara beaudoux
@clarabdx

A lot of loose photographs in these boxes, but here's an album that's been painstakingly put together #Madeleineproject

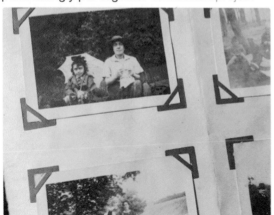

RETWEET J'AIME
1 9

11:03 - 5 nov. 2015

clara beaudoux
@clarabdx

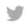

I instantly recognize you in the pictures now, Madeleine #Madeleineproject

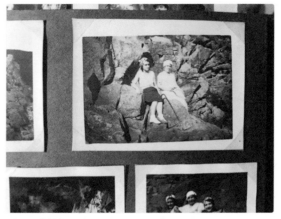

RETWEET 1 J'AIME 22

11:05 - 5 nov. 2015

clara beaudoux
@clarabdx

I know who it is in this one. #Madeleineproject

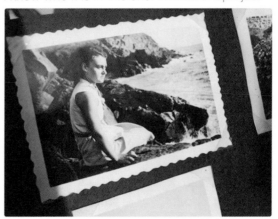

J'AIME
6

11:08 - 5 nov. 2015

clara beaudoux
@clarabdx

It's the one you decided to have framed, I saw it in another box #Madeleineproject

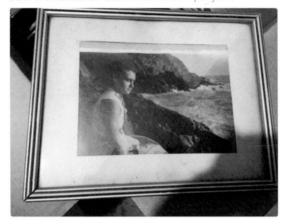

J'AIME
8

11:08 - 5 nov. 2015

clara beaudoux
@clarabdx

I'll take a picture of these ones, too, because of the little #chats #cat #lolcat #Madeleineproject

RETWEETS J'AIME
2 12

11:10 - 5 nov. 2015

clara beaudoux
@clarabdx

And I realize that you decided to have one of these framed, too #Madeleineproject

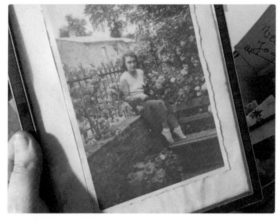

RETWEETS 2 J'AIME 7

11:11 - 5 nov. 2015

clara beaudoux
@clarabdx

The album isn't completely full, there are some blank pages, but at the very end... #Madeleineproject

11:14 - 5 nov. 2015

SEASON 1

clara beaudoux
@clarabdx

At the very end, all of a sudden, rows and rows of little Madeleines, wow! #Madeleineproject

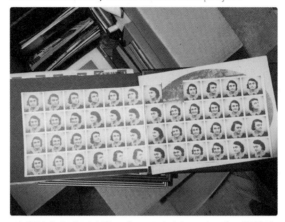

RETWEETS 15 J'AIME 46

11:18 - 5 nov. 2015

clara beaudoux
@clarabdx

You look really sweet and funny in this one, Madeleine #Madeleineproject

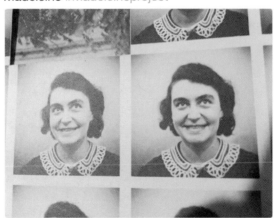

RETWEETS 17 J'AIME 48

11:20 - 5 nov. 2015

clara beaudoux
@clarabdx

In this box there is also a little flask of holy
water from Lourdes, but hey, it's empty… Did
you really believe in it? #Madeleineproject

J'AIME
10

11:25 - 5 nov. 2015

clara beaudoux
@clarabdx

I opened a sort of little cardboard envelope
held in place by a fine string: little notebooks
#Madeleineproject

RETWEETS J'AIME
4 7

11:28 - 5 nov. 2015

clara beaudoux
@clarabdx

In fact they're tiny little datebooks, and you couldn't make up that name—Mignon, how cute! #Madeleineproject

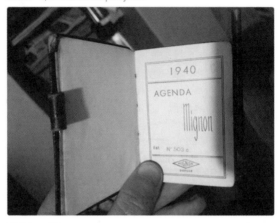

RETWEETS J'AIME
4 16

11:30 - 5 nov. 2015

clara beaudoux
@clarabdx

This one is "ideal," there's one for every year from 1937 to 1942 #Madeleineproject

J'AIME
7

11:32 - 5 nov. 2015

The writing is absolutely tiny, and here too
you mention "Jacques" #Madeleineproject

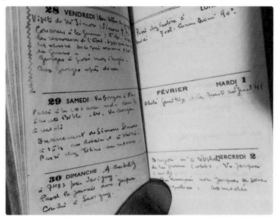

11:35 - 5 nov. 2015

There are also some schoolgirl's notebooks,
including this one from October 1925, you
were ten years old #Madeleineproject

11:39 - 5 nov. 2015

clara beaudoux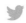
@clarabdx

And loads more trips: Holland, Bruges,
Italy, Istanbul, Florence, Lower Normandy
#Madeleineproject

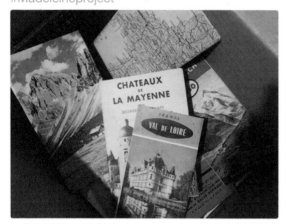

J'AIME
6

11:45 - 5 nov. 2015

DAY 4

clara beaudoux
@clarabdx

And because you liked to travel so much,
Madeleine, these tweets are now available
in English, here @Madeleine_EN
#MadeleineprojectEN

RETWEETS J'AIME
5 10

11:52 - 5 nov. 2015

clara beaudoux
@clarabdx

And since we're talking PR, the Facebook page is here: facebook.com/madeleineproje…

RETWEETS J'AIME
2 4

11:53 - 5 nov. 2015

clara beaudoux
@clarabdx

But what about that suitcase, anyway?
#Madeleineproject

RETWEETS J'AIME
3 2

11:57 - 5 nov. 2015

 clara beaudoux
@clarabdx

For a start, on top, there's a packet of pictures showing lots of beautiful things on earth #Madeleineproject

J'AIME
5

12:07 - 5 nov. 2015

 clara beaudoux
@clarabdx

First of all, there are stars, and on the left is a caption: "Northern half of the Veil Nebula" #Madeleineproject

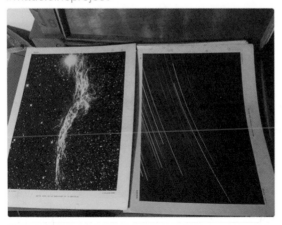

RETWEET J'AIME
1 16

12:09 - 5 nov. 2015

clara beaudoux
@clarabdx

And in the box next to it is all your own lace,
Madeleine #Madeleineproject

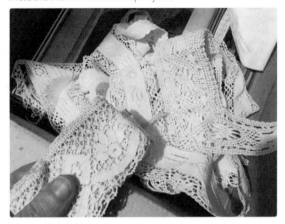

J'AIME
14

12:09 - 5 nov. 2015

clara beaudoux
@clarabdx

And then there's a pile of press clippings,
the kind that leave a strong impression…
#Madeleineproject

RETWEET J'AIME
1 5

12:12 - 5 nov. 2015

clara beaudoux
@clarabdx

Because I've never seen this name in the headlines before (January 1945)
#Madeleineproject

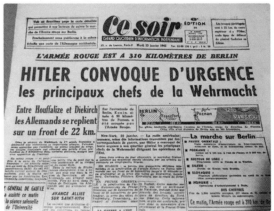

RETWEETS 8 J'AIME 17

[Hitler Urgently Summons Top Wehrmacht Leaders]

12:14 - 5 nov. 2015

clara beaudoux
@clarabdx

On the maps someone highlighted a whole slew of cities in blue #Madeleineproject

J'AIME
5

12:16 - 5 nov. 2015

clara beaudoux
@clarabdx

There are clippings from December 1944
to April 1945, just before the end of the war
#Madeleineproject

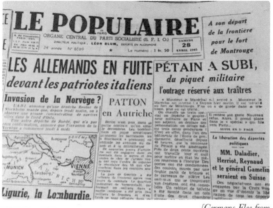

*[Germans Flee from
Italian Patriots]*

RETWEETS | J'AIME
4 | 8

12:19 - 5 nov. 2015

clara beaudoux
@clarabdx

There's this cartoon of Germany going to
pieces #Madeleineproject

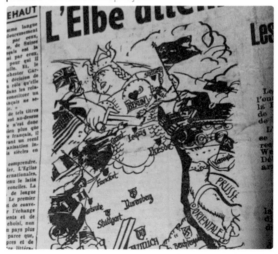

J'AIME
4

12:21 - 5 nov. 2015

There's also a clipping from 1947:
General Leclerc's burial at Les Invalides
#Madeleineproject

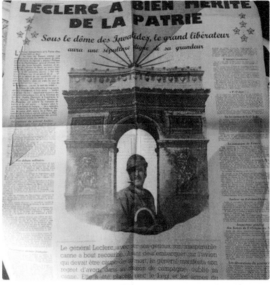

J'AIME
5

12:27 - 5 nov. 2015

clara beaudoux
@clarabdx

And then, in the suitcase, beneath all the pictures of the world at large and the clippings about the war, I found this #Madeleineproject

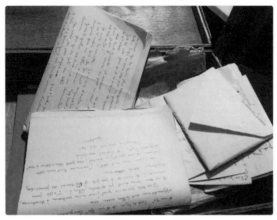

RETWEETS J'AIME
4 8

12:31 - 5 nov. 2015

clara beaudoux
@clarabdx

Letters, loads of them, whole bundles, a yellow one, a blue one #Madeleineproject

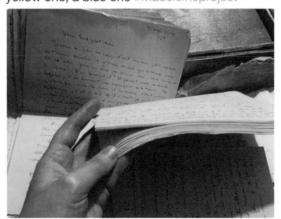

RETWEETS J'AIME
4 12

12:33 - 5 nov. 2015

clara beaudoux
@clarabdx

Allow me to introduce "Loulou"
#Madeleineproject

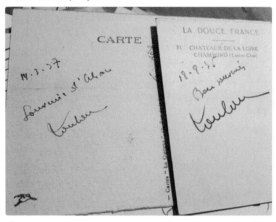

RETWEETS J'AIME
2 12

12:34 - 5 nov. 2015

clara beaudoux
@clarabdx

In 1935, in 1937, he sent postcards to the
family, "Remember me to…" "Dear friends…"
#Madeleineproject

J'AIME
6

12:35 - 5 nov. 2015

clara beaudoux
@clarabdx

These bundles of letters—I initially thought they
were from a father to his daughter, where he says,
"My little girl" #Madeleineproject

J'AIME
6

12:38 - 5 nov. 2015

clara beaudoux
@clarabdx

And then just by chance I read the one from
"October 11, 1939, 9:30 p.m." #Madeleineproject

J'AIME
5

12:40 - 5 nov. 2015

clara beaudoux
@clarabdx

"My little girl…" #Madeleineproject

J'AIME
6

12:41 - 5 nov. 2015

clara beaudoux
@clarabdx

"Put your mind at rest, my little darling, I
haven't forgotten my beloved little woman"
#Madeleineproject

RETWEETS J'AIME
3 15

12:42 - 5 nov. 2015

clara beaudoux
@clarabdx

"And I'll write to her as often as I can."
#Madeleineproject

RETWEET J'AIME
1 6

12:43 - 5 nov. 2015

clara beaudoux
@clarabdx

"As I am sure she will do likewise, I kiss her on her little neck" #Madeleineproject

RETWEET J'AIME
1 13

12:43 - 5 nov. 2015

clara beaudoux
@clarabdx

They recommend books to each other, Loulou tells her about his "anti-butterfly screens" (?) #Madeleineproject

J'AIME
8

12:45 - 5 nov. 2015

clara beaudoux
@clarabdx

"Autumn is drawing on: the woods are magnificent, the leaves are turning yellow, with superb colors" #Madeleineproject

RETWEETS J'AIME
3 17

12:46 - 5 nov. 2015

clara beaudoux
@clarabdx

"Such a pity, as I've said, that it's all in a state of siege" writes Loulou (1939) #Madeleineproject

J'AIME
5

12:47 - 5 nov. 2015

 clara beaudoux
@clarabdx

Loulou says he received her letters: "Keep writing to me, my little girl, tell me about yourself, what you're doing there" #Madeleineproject

J'AIME
9

12:53 - 5 nov. 2015

 clara beaudoux
@clarabdx

"Tell me about yourself, tell me everything, so I'll be with you as much as I can, despite the distance keeping us apart" #Madeleineproject

RETWEETS J'AIME
3 28

12:53 - 5 nov. 2015

 clara beaudoux
@clarabdx

I have figured out she's in Aix, and he's in Paris #Madeleineproject

J'AIME
7

12:54 - 5 nov. 2015

 clara beaudoux
@clarabdx

"You tell me, my little dumpling, that you regret the good times we had together during the holidays" #Madeleineproject

RETWEET J'AIME
1 10

12:55 - 5 nov. 2015

clara beaudoux
@clarabdx

"You mustn't regret it, on the contrary, you must just keep all the good memories"
#Madeleineproject

RETWEETS J'AIME
4 23

12:56 - 5 nov. 2015

clara beaudoux
@clarabdx

"If you like, we can regret we didn't enjoy ourselves even more, and then some." #Madeleineproject

RETWEETS J'AIME
4 20

12:56 - 5 nov. 2015

clara beaudoux
@clarabdx

(He seemed like a good guy, Madeleine, your Loulou) #Madeleineproject

RETWEETS J'AIME
2 28

12:56 - 5 nov. 2015

clara beaudoux
@clarabdx

At first I thought these letters were for a child, because sometimes he calls you "my little Kiki," which later becomes "my little Ki"
#Madeleineproject

J'AIME
4

13:02 - 5 nov. 2015

clara beaudoux
@clarabdx

"I'll see you soon, my little dumpling, I kiss you the way I love you" — You were 24 years old, Madeleine #Madeleineproject

RETWEETS 10 J'AIME 21

13:03 - 5 nov. 2015

clara beaudoux
@clarabdx

And then I saw that you had numbered each letter, Madeleine… #Madeleineproject

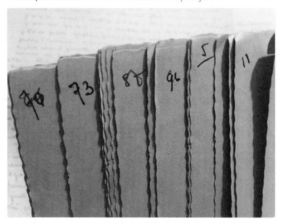

RETWEETS 5 J'AIME 13

13:07 - 5 nov. 2015

 clara beaudoux
@clarabdx

Madeleine also wrote down the date she received
the letters #Madeleineproject

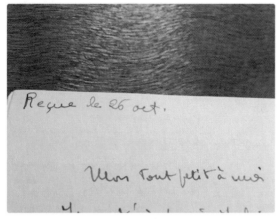

J'AIME
7

13:14 - 5 nov. 2015

 clara beaudoux
@clarabdx

But I get the feeling there are a few missing?
#Madeleineproject

J'AIME
4

13:10 - 5 nov. 2015

clara beaudoux
@clarabdx

The letters are very close together between
September 1939 and May 1940 #Madeleineproject

RETWEET J'AIME
1 4

13:15 - 5 nov. 2015

clara beaudoux
@clarabdx

Loulou complained that the mail was too slow,
"I doubt it can go any faster, we'll have to get
used to it" #Madeleineproject

RETWEET J'AIME
1 10

13:16 - 5 nov. 2015

clara beaudoux
@clarabdx

As of May 15, 1940, the dates of the letters are
very far apart: one in July, one in September, one
in March for her birthday #Madeleineproject

RETWEET J'AIME
1 4

13:19 - 5 nov. 2015

clara beaudoux
@clarabdx

In July 1940, Loulou wrote to Madeleine that
"Jacques" (again) had been "taken prisoner
in Germany" but was "in good health"
#Madeleineproject

J'AIME
5

13:23 - 5 nov. 2015

clara beaudoux
@clarabdx

There are letters from Loulou until 1943, it seems he was still in Paris #Madeleineproject

J'AIME
4

13:26 - 5 nov. 2015

clara beaudoux
@clarabdx

Then after 1943, what happened to Loulou? And between you and Loulou? #Madeleineproject

RETWEETS J'AIME
2 4

13:27 - 5 nov. 2015

clara beaudoux
@clarabdx

I'll have to find time to read all these letters, I'll do it at a later date #Madeleineproject

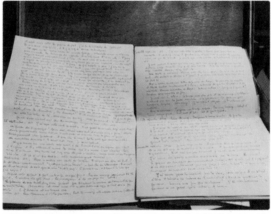

RETWEET J'AIME
1 14

13:28 - 5 nov. 2015

In any case, I've realized one thing, Madeleine: this was Loulou's suitcase #Madeleineproject

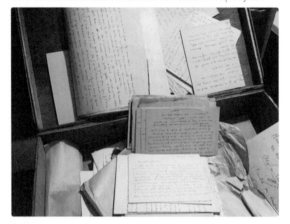

RETWEETS J'AIME
6 20

13:31 - 5 nov. 2015

 clara beaudoux
@clarabdx

SEASON 1

I'll take good care of it, actually it's the only suitcase I've taken up to my apartment #Madeleineproject

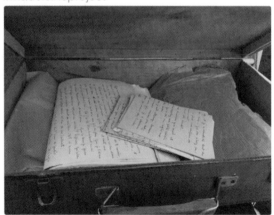

RETWEETS J'AIME
5 17

13:32 - 5 nov. 2015

And to conclude, a picture in keeping
with the theme: Madeleine's cake tins
#Madeleineproject

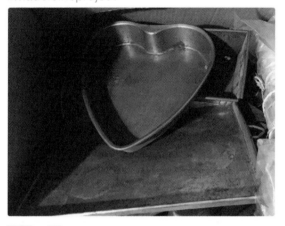

RETWEETS J'AIME
7 23

13:34 - 5 nov. 2015

DAY 4

And my own little heart in awe, realizing this great
gift you have left for me #Madeleineproject More
tomorrow

RETWEETS J'AIME
18 91

13:36 - 5 nov. 2015

 clara beaudoux
@clarabdx

Sometimes I wonder if I'll ever get through
everything in this cellar, all your lovely things
#Madeleineproject

RETWEET J'AIME
1 19

10:36 - 6 nov. 2015

clara beaudoux
@clarabdx

I opened this little box, it went "pok," and a little cloud of white smoke came out
#Madeleineproject

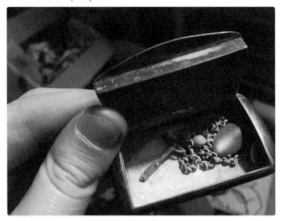

RETWEETS J'AIME
2 17

10:38 - 6 nov. 2015

clara beaudoux
@clarabdx

And here's Bourges, where you were born
#Madeleineproject

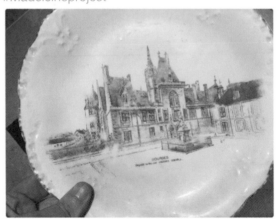

J'AIME
4

10:41 - 6 nov. 2015

clara beaudoux
@clarabdx

And what on earth is this? What do you put in it?
#Madeleineproject

J'AIME
3

10:42 - 6 nov. 2015

clara beaudoux
@clarabdx

So chic, you even have a fur coat. Yup,
I think Madeleine had a certain status
#Madeleineproject

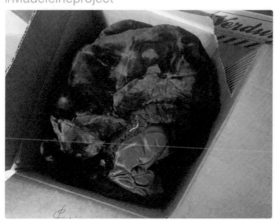

J'AIME
5

10:45 - 6 nov. 2015

clara beaudoux
@clarabdx

(I didn't feel like trying it on)

10:45 - 6 nov. 2015

clara beaudoux
@clarabdx

And I'll go ahead and say it, there are some
pretty ugly things in this cellar, too
#Madeleineproject

RETWEET J'AIME
1 5

10:46 - 6 nov. 2015

clara beaudoux
@clarabdx

Like this, for example #Madeleineproject

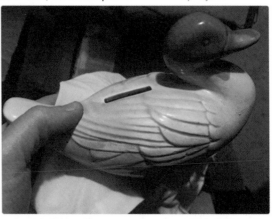

J'AIME
11

10:49 - 6 nov. 2015

clara beaudoux
@clarabdx

And then this chandelier. Trying to picture it in my (our) apartment… #Madeleineproject

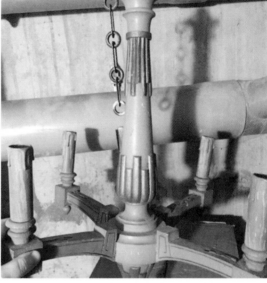

109

RETWEET J'AIME
1 4

10:51 - 6 nov. 2015

clara beaudoux
@clarabdx

Now back to a suitcase from the very
beginning, to take another, closer look
#Madeleineproject

RETWEETS J'AIME
3 7

10:54 - 6 nov. 2015

clara beaudoux
@clarabdx

This is the suitcase where there was the envelope
about Martial #Madeleineproject

clara beaudoux @clarabdx
Dans l'enveloppe "Martial" (son frère ?) il y a sa plaque de l'armée,
son permis, et une lettre... #Madeleineproject

J'AIME
1

10:58 - 6 nov. 2015

*[In the "Martial" envelope (her brother?) there
is his dog tag from the army, his driver's
license, and a letter... #Madeleineproject]*

clara beaudoux
@clarabdx

Well, thanks to the superb efforts of
@Freddinette and @HerveMarchon we now know
that: #Madeleineproject

J'AIME
2

10:59 - 6 nov. 2015

clara beaudoux
@clarabdx

Martial wasn't her brother, but her cousin!
#Madeleineproject

J'AIME
13

10:59 - 6 nov. 2015

DAY 5

clara beaudoux
@clarabdx

Madeleine, it seems, was an only child
#Madeleineproject

111

RETWEETS J'AIME
4 3

11:02 - 6 nov. 2015

clara beaudoux
@clarabdx

Her mother's name was Raymonde (yes the same
Raymonde from the tea set) #Madeleineproject

clara beaudoux @clarabdx
Il y a aussi le service à thé de Raymonde. C'est qui Raymonde ?
#Madeleineproject

J'AIME
4

11:04 - 6 nov. 2015

*[Then there's this tea set that belonged
to Raymonde. Who was Raymonde?
#Madeleineproject]*

clara beaudoux
@clarabdx

Her father's name was Henri. "Henri Raymonde Madeleine" #Madeleineproject

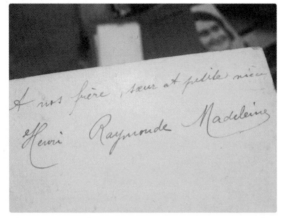

RETWEET J'AIME
1 6

11:07 - 6 nov. 2015

clara beaudoux
@clarabdx

Here they are, all three of them #Madeleineproject

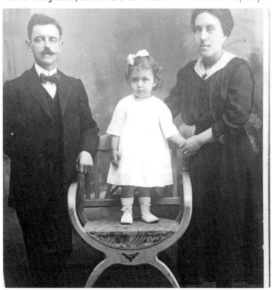

RETWEETS J'AIME
9 48

11:08 - 6 nov. 2015

clara beaudoux
@clarabdx

Oh, little Madeleine… #Madeleineproject

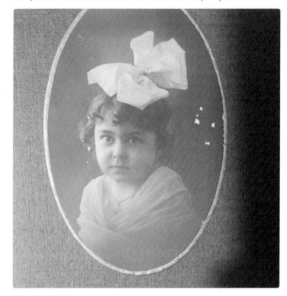

RETWEETS J'AIME
6 49

113

clara beaudoux
@clarabdx

Hard to go back any further than "Madeleine aged three months is sending you her photo" Raymonde writes on the back: #Madeleineproject

J'AIME
6

11:14 - 6 nov. 2015

clara beaudoux
@clarabdx

Baby Madeleine is in the photo in the gray frame,
already traveling… #Madeleineproject

J'AIME
20

11:15 - 6 nov. 2015

114

clara beaudoux
@clarabdx

In fact I think you collected four-leafed
clovers #Madeleineproject

J'AIME
18

11:18 - 6 nov. 2015

SEASON 1

 clara beaudoux
@clarabdx

Ah I forgot to tell you about this big magnifying glass I found, source of great photographic inspiration... #Madeleineproject

J'AIME
3

11:39 - 6 nov. 2015

clara beaudoux
@clarabdx

(Yes I spent some time with it!)
#Madeleineproject

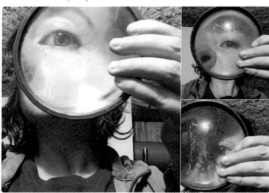

J'AIME
12

11:41 - 6 nov. 2015

clara beaudoux
@clarabdx

And now, I do have to tell you one thing…
#Madeleineproject

RETWEET J'AIME
1 2

11:44 - 6 nov. 2015

clara beaudoux
@clarabdx

In this suitcase I went back into, things were
different #Madeleineproject

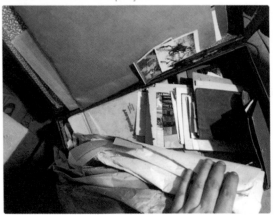

RETWEETS J'AIME
2 6

11:47 - 6 nov. 2015

clara beaudoux
@clarabdx

Because now I know you a bit better
#Madeleineproject

J'AIME
5

11:47 - 6 nov. 2015

116

SEASON 1

clara beaudoux
@clarabdx

At the bottom of the suitcase, nice and flat, a
white envelope with a cross on the upper left
hand side #Madeleineproject

J'AIME
2

11:49 - 6 nov. 2015

clara beaudoux
@clarabdx

The envelope is sealed. Closed.
#Madeleineproject

J'AIME
4

11:50 - 6 nov. 2015

clara beaudoux
@clarabdx

117

I hesitated. And then I took a little pair of
rusty silver plated scissors from one of the boxes
#Madeleineproject

J'AIME
9

11:52 - 6 nov. 2015

clara beaudoux
@clarabdx

And very carefully I cut it open. This is the
only time in all these days I've felt I was doing
something I shouldn't #Madeleineproject

J'AIME
11

11:56 - 6 nov. 2015

 clara beaudoux
@clarabdx

A little announcement, with black edges. I'd seen his name the day before on a business card in his suitcase #Madeleineproject

RETWEET 1 J'AIME 6

12:00 - 6 nov. 2015

 clara beaudoux
@clarabdx

Loulou died "November 23, 1943, at the age of 31" #Madeleineproject

RETWEETS 9 J'AIME 17

12:03 - 6 nov. 2015

 clara beaudoux
@clarabdx

And today, in fact, is my 31st birthday...
#Madeleineproject

RETWEETS 4 J'AIME 35

12:07 - 6 nov. 2015

 clara beaudoux
@clarabdx

Loulou was a "licensed attorney," the announcement says in capital letters, just below his name #Madeleineproject

J'AIME 5

12:10 - 6 nov. 2015

 clara beaudoux
@clarabdx

How did Loulou die? I don't know, but this has been the most emotional moment for me, down here in this cellar #Madeleineproject

RETWEETS J'AIME
9 37

12:11 - 6 nov. 2015

 clara beaudoux
@clarabdx

Loulou's last letter dates from March 1, 1943, what happened between March and November? #Madeleineproject

RETWEET J'AIME
1 4

12:15 - 6 nov. 2015

DAY 5

 clara beaudoux
@clarabdx

119

He didn't mention anything in particular, his closing words were to kiss "his little woman [he] loves more than anything" #Madeleineproject

RETWEET J'AIME
1 4

12:15 - 6 nov. 2015

 clara beaudoux
@clarabdx

On the announcement it says "from": "Mr and Mrs *Loulou*, his Parents; Mademoiselle Madeleine, his Fiancée" #Madeleineproject

J'AIME
10

12:19 - 6 nov. 2015

clara beaudoux
@clarabdx

There's something else, and that's the business with the envelope, but it's hard to explain :-/ #Madeleineproject

J'AIME
5

12:26 - 6 nov. 2015

 clara beaudoux
@clarabdx

I'll try. In fact, the announcement about Loulou was in a sealed envelope which had another death announcement in it #Madeleineproject

J'AIME
4

12:30 - 6 nov. 2015

 clara beaudoux
@clarabdx

The other announcement is from 1972, and it was for your godmother #Madeleineproject

J'AIME
3

12:32 - 6 nov. 2015

 clara beaudoux
@clarabdx

And the envelope is the size of your godmother's death announcement #Madeleineproject

J'AIME
3

12:32 - 6 nov. 2015

 clara beaudoux
@clarabdx

So in 1972 you put Loulou's death announcement
(much smaller) into this envelope, and then you
sealed it #Madeleineproject

J'AIME
4

12:33 - 6 nov. 2015

 clara beaudoux
@clarabdx

In 1972… So where had you been keeping Loulou's
announcement, all that time since
1943? #Madeleineproject

RETWEET J'AIME
1 5

12:34 - 6 nov. 2015

 clara beaudoux
@clarabdx

121

Did it take you thirty years to finally put it
away? #Madeleineproject

RETWEET J'AIME
1 8

12:37 - 6 nov. 2015

 clara beaudoux
@clarabdx

And now it's clearer to me why you
numbered his letters #Madeleineproject

 clara beaudoux @clarabdx
Et là je réalise que tu as numéroté les lettres, Madeleine…
#Madeleineproject

J'AIME *[And then I saw that you had numbered each letter,*
6 *Madeleine… #Madeleineproject]*

12:42 - 6 nov. 2015

clara beaudoux
@clarabdx

I found a letter from Madeleine to Loulou
which never reached its destination
#Madeleineproject

RETWEET J'AIME
1 8

12:50 - 6 nov. 2015

clara beaudoux
@clarabdx

It is from "June 6 1940 5 p.m."
#Madeleineproject

RETWEET J'AIME
1 5

12:51 - 6 nov. 2015

clara beaudoux
@clarabdx

"Dear boy, I must start right away with the
most unpleasant thing, which is to scold
you, Monsieur." #Madeleineproject

J'AIME
6

12:55 - 6 nov. 2015

clara beaudoux
@clarabdx

She says she got a letter from a woman who wrote
that on Sunday "20 airplanes flew over" Loulou's
place #Madeleineproject

J'AIME
4

12:57 - 6 nov. 2015

clara beaudoux
@clarabdx

"The machine guns were firing" writes
Madeleine #Madeleineproject

J'AIME
3

12:57 - 6 nov. 2015

clara beaudoux
@clarabdx

"And Loulou stood there watching" the woman
said to Madeleine, "Well! That isn't nice at all!"
wrote Madeleine to Loulou #Madeleineproject

J'AIME
3

12:59 - 6 nov. 2015

clara beaudoux
@clarabdx

"I learn that you stand there staring at the sky,
watching them go by" #Madeleineproject

J'AIME
2

13:01 - 6 nov. 2015

clara beaudoux
@clarabdx

"Look out the window, if you have to, but don't
stay outside, please!" #Madeleineproject

J'AIME
2

13:02 - 6 nov. 2015

clara beaudoux
@clarabdx

Madeleine isn't doing too well: "Everything disgusts me. I can't get started on anything, I hardly read any more" #Madeleineproject

RETWEET J'AIME
1 3

13:04 - 6 nov. 2015

clara beaudoux
@clarabdx

"But I have to react" she says; she's not the type to get discouraged, my Madeleine #Madeleineproject

J'AIME
10

13:06 - 6 nov. 2015

124

clara beaudoux
@clarabdx

And then further along she refers to their first time, I think, and we'll keep that to ourselves #Madeleineproject

RETWEET J'AIME
1 20

13:07 - 6 nov. 2015

SEASON 1

clara beaudoux
@clarabdx

I'll just share one thing you said: "it's every bit as beautiful, as sweet" #Madeleineproject

J'AIME
17

13:08 - 6 nov. 2015

clara beaudoux
@clarabdx

And you concluded: "It's a comfort to love one another so well, isn't it, dear boy, particularly nowadays!" #Madeleineproject

RETWEETS 8 J'AIME 25

13:11 - 6 nov. 2015

clara beaudoux
@clarabdx

"Goodbye, my beloved Loulou." #Madeleineproject

RETWEETS 3 J'AIME 17

13:12 - 6 nov. 2015

clara beaudoux
@clarabdx

There, I think I've covered everything I wanted to this week, in this cellar #Madeleineproject

RETWEET 1 J'AIME 5

13:14 - 6 nov. 2015

DAY 5

125

clara beaudoux
@clarabdx

There are still a lot of things to go through: photographs, documents, Loulou's letters. I had no idea there'd be so much... #Madeleineproject

J'AIME
5

13:15 - 6 nov. 2015

clara beaudoux
@clarabdx

And so many questions: what should I do with it all now? What would you have thought? #Madeleineproject

J'AIME
9

13:16 - 6 nov. 2015

clara beaudoux
@clarabdx

And then, who is she, the woman who draws snowmen on her letters? #Madeleineproject

J'AIME
9

13:17 - 6 nov. 2015

 clara beaudoux
@clarabdx

I'd also like to know where you are buried, and how you arranged our apartment #Madeleineproject

RETWEETS J'AIME
2 15

13:18 - 6 nov. 2015

 clara beaudoux
@clarabdx

On the balcony, when I arrived, there were a lot of seeds, it looks like you used to feed the birds #Madeleineproject

J'AIME
8

13:20 - 6 nov. 2015

DAY 5

 clara beaudoux
@clarabdx

127

In short, let's say this is the end of Season 1 of the #Madeleineproject

RETWEETS J'AIME
2 12

13:20 - 6 nov. 2015

 clara beaudoux
@clarabdx

Something a bit magical happened in the midst of it all, it felt as if I was opening the boxes in the right order #Madeleineproject

J'AIME
17

13:21 - 6 nov. 2015

clara beaudoux
@clarabdx

Thanks to everyone for taking part and writing to me. And for your theories, however eccentric ;-) #Madeleineproject

RETWEET J'AIME
1 21

13:22 - 6 nov. 2015

 clara beaudoux
@clarabdx

Oh, but wait... and what about this suitcase?
#Madeleineproject

J'AIME
13

13:28 - 6 nov. 2015

clara beaudoux
@clarabdx

I go over, the clasps click open in the silence, and... #Madeleineproject

0:07 / 0:10

RETWEETS J'AIME
3 13

13:32 - 6 nov. 2015

DAY 5

clara beaudoux
@clarabdx

And then...? To be continued... #Madeleineproject 129
If you want to keep abreast of any further developments: facebook.com/madeleineproje...
See you soon, thanks!!

RETWEETS J'AIME
12 19

13:35 - 6 nov. 2015

 clara beaudoux
@clarabdx

~ To Madeleine. ~

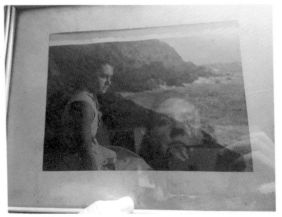

RETWEETS J'AIME
18 84

13:36 - 6 nov. 2015

Time had to stand still

"My working hypothesis was that any fairly long memory is more structured than it might seem. And that photographs taken apparently at random, or postcards chosen according to the mood of the moment will, once they reach a certain number, begin to track an itinerary, to map the imaginary country whose expanse lies within us."
—Chris Marker

I'D BEEN DRIFTING FROM one studio apartment to another for several years already. I didn't feel at home anywhere. In July 2013 I ended up in this little place. And I never suspected that the secrets it concealed might one day lead to a book.

My first notes about Madeleine are scattered on loose sheets of paper, in a folder where I keep the lease, the receipts from the rent, and the record of my apartment's energy use. I knew from my earliest weeks here that I had to preserve a trace of this woman's life. Today I still wonder why, instinctively, I felt this was important. I had added the little gray metal plate from the mailbox, with her last name, to the file. I had also kept some junk mail from an insurance company, and that's how I'd found

out her first name, on the envelope. In this manila folder there is also a diagram the real estate agency gave me, showing the cellar storage rooms in the building. Storage room 16 was circled. I never dreamed I'd spend so much time down there.

I remember I already began wondering about Madeleine when I was cleaning the apartment, before moving in. On the floor of the balcony, the gaps between the stones were full of bird seed. The ventilator in the kitchen, on the other hand, was grimy with old cooking fat. My father reckons she must have cooked French fries on a regular basis over the years.

In the beginning I made a few brief visits to the cellar. But my work didn't allow me the time for a more thorough investigation into the things that were stored there. Besides, what would I do with all the stuff I might find between those four walls? I went down there only a few times to tidy up a bit and throw out things that were decaying. But I did think it might be useful to take a picture of every item I threw out. It was as if I felt instinctively that I ought to do something with it, that I couldn't just get rid of everything. For example, I have a photograph of a single mattress. The label says: "tranquility and elegance," with a picture of a woman lying serenely on it—quite the opposite from the actual state of the mattress, which was rotting, covered with a plastic sheet meant to protect the rest of the things from the slime oozing out of it.

Incidentally, I was amazed by the range of colors that putrefaction can confer on things.

I gave a vase I found in the cellar to the real estate agent who had helped me find the apartment. When he heard about my project, he offered to give it back. I remember asking him "where" when he told me that the previous tenant had died. At the time, I didn't believe in ghosts, but you never know.

My family came to go through some of the things with me, and I took a few pictures. Those are the items I used at the very beginning of "Season 1." Then next to them I placed my tent, my Moon Boots for the three days of snow we get in a year in Paris, my African drum—yes, I know!—the Ikea coffee table I don't use any more, the empty box for my television in lieu of the empty box that contained her TV, and then I locked it all back up with a padlock. For the time being.

•

Until 2015. I had decided that 2015 would be my "year of radical change." Which meant I planned to follow my desires, and mine alone; I was tired of going along with what other people wanted, of making do with a minimum, of being reasonable. "Radical": the word has taken on a whole new significance, obviously, given the tragic terrorist attacks in Paris in 2015.

I wanted to get away from the news, and I became passionately interested in documentaries. I realized then how important it was to accept one's own state of mind. Someone also advised me, one day, to "follow my heart."

It's difficult to explain how all these new directions led me to the idea of live-tweeting the contents of my cellar … Whatever the case may be, the day before I began Season 1, I wrote to my brother: "I feel as if I'm about to fall into space." And he said, "Go for it, jump!"

At the same time as I was tweeting, I began to keep a logbook, to write down my impressions as I went along. To my great surprise, my Season 1 very quickly reached a large audience on social media. And there I was in the middle of the whirlwind, when I'm used to being behind the scenes, among my fellow journalists. It was a bit scary, I must confess.

At the same time I was very moved to see that such minutiae could be of so much interest to Internet users of all ages. These tiny little details, these micro-memories, dried petals, worn pencils … All the beauty of everyday things, which so often we forget to observe, could come to life. The fact that such an infinitesimal world could touch so many people restored some of my trust in who we are, and in what we can love. So I clung to this idea.

I was also struck by how many people came to my aid, and I am grateful to them. Dozens of people, from amateur genealogists ready to identify Madeleine's ancestors and parents and grandparents and cousins and aunts, to all the Internet users who were prepared to imagine this woman's life. Madeleine's story became a story we could all share, as well as a story between her and me.

I didn't sleep well at all that first week. In my head I was composing every tweet. I began to speak to her directly, spontaneously, initially in my thoughts alone, but then I checked my urge to say "you" to this woman I was discovering only gradually. Until I accepted the fact that we had embarked on this adventure together, and that after "I" there had to be "you," and our relationship was bound to become part of the story. There was one insoluble question that continued to torment me, however: What would you have made of all this, Madeleine? As there was no answer, I did everything I could to be as respectful of your life as possible. I embarked on this investigation with the greatest consideration I could possibly feel, toward her, and every item of her belongings. Even my gestures were tentative and careful, when opening her letters, or moving things around to photograph them: I mustn't damage anything.

And suddenly I was assailed by self-doubt: Did I have the right? To show other people your things like this? Your life? Would you be angry with me? Do you "see me?" Does coincidence exist? Does magic exist? Why did I wait two whole years? Why have I started doing this? Why does this work resonate with me like this? And between you and me? And what about all the people who have shown an interest in the project? Could somebody sue me? The next time someone rings my bell, could it be a summons to appear in court? What if someone comes to take everything away? And what will the neighbors think? The ones who used to know you? What will they say? Will they be angry with me? Do I have the right to

question your secret garden in this way? How can I lift the veil without betraying you? Can one really be afraid of betraying a person one does not know? But haven't I come to know you a little, in the end?

Why did you keep so many things? Why did you put them away so neatly? Did you hope someone might find them someday? What would you have done if you'd found someone's things like this? Why do some people keep everything, while others throw everything away?

What did you used to think about, Madeleine? What sort of dreams did you have? What sort of landscapes did you like? What affected you? How did you view life? What was your voice like? How did you imagine your future with Loulou? Did you ever recover from his death? How did the world appear to you? And the afterlife? What, as a woman, did you desire, what were your joys, what made you angry, what did you believe in?

Why print all these tweets? Why print something so ethereal? To keep a trace? To preserve the memory of your memory?

Is it a struggle against forgetting? Against obliteration? Against death? Why am I so interested in you? When I've never done anything like this for my own grandparents, who are now deceased? What will be left of us?

•

And then, after an intensely beautiful week, there came November 13 when radical Islamic gunmen left 130 peo-

ple dead and nearly 500 wounded all over Paris. A veil of sadness fell over everything.

I let some time go by before returning to my investigation. One Internet user came upon the Madeleine project just after the attacks. He wrote to me that it "restored his faith in life." And I told myself that beauty would be my weapon. I decided to adhere to this radical line, that of "listening to your heart."

A line to remain "just," to keep on the right path. This is what I believe, and I don't want to follow anything else from now on. The moment I immerse myself in the project again, my heart aches, I'm short of breath. As long as I feel this, I'll be okay. It's only when I no longer feel anything that I'll have to call it all off.

Bit by bit, I began to dream about Madeleine. I saw myself as a little girl in my high chair, and she stood behind me wearing sunglasses; or maybe we were two little girls playing together. I felt guilty, too, when I had to work on other projects for a few weeks. It was as if I were abandoning her. In fact, I'm afraid that one day this project will disappear, slip out of my hands, vanish into thin air, as if it were only a passing dream …

•

My thoughts on the matter then developed further, because I was called on more and more to speak about the project. I love this work because it's something I can do on my own, without a boss, without any pressure, without

having to obey any pre-existing format. No one to tell me how I should be "reporting," adopting a documentary, literary, or fictional approach. No one to stipulate whether I must include sound, image, video. With Madeleine I am totally free, and that is what has made this story possible. I truly believe that this freedom is precious, and that it has broadened the scope of possibilities.

I remember a man from the radio who told me that the most poignant reportages are not necessarily to be found at the far ends of the earth, but sometimes just around the corner. All I had to do was open a door, the door to my cellar, for the adventure to begin. I find it very moving, the way this project has become inclusive, creating ties among people, when you think that Madeleine ended her life so very alone. I also find it touching that so many people now take an interest in every one of her possessions, possessions that should have ended up in the dumpster. Finally, I think it's fantastic that through this story so many people have found their grandparents, their stories, their memories, their attics, their remembrances. So many grandmothers also called Madeleine! Someone said, "Something very private and personal has connected with the universal."

We should always study history in this way: it should always be incarnated. After all, insignificant people too have made History, not just the great men that history books talk about. And women, too. I am so happy to have come upon a woman in that cellar.

·

When I think about it, I believe that Madeleine has offered me a unique space to express myself. Because she has urged me to say "I," while still leaving me a place to hide—behind her. It is as if she held out her hand, and walked with me, to reach the threshold of a world between dream and reality, between presence and absence, between what has been and what is. This space between the two, this fault line, this silence where, no doubt, poetry is born.

For this book, time had to stand still, the Twitter flow had to stop at a precise moment. All the thoughts I've relegated to these pages are also thoughts that are valid in this very instant. An instant that will endure, frozen in time, the way time itself was frozen in my cellar, between those four cold, damp walls. But the investigation will go on. In search of … ? I can almost hear you asking me, Madeleine. We shall see.

Clara Beaudoux
February 2016

SEASON 2

DAY 1

141

 clara beaudoux
@clarabdx

#Madeleineproject – Season 2 – madeleineproject.
fr

RETWEETS J'AIME
25 23

11:00 - 8 févr. 2016

 clara beaudoux
@clarabdx

The #Madeleineproject began three months
ago, and it seems like an eternity, given everything
that has happened since.

RETWEETS J'AIME
2 11

11:05 - 8 févr. 2016

clara beaudoux
@clarabdx

After the attacks, Madeleine's words echoed
in my mind, "It's such a comfort to love each
other so well, dear boy, especially now"

RETWEETS J'AIME
11 32

11:05 - 8 févr. 2016

clara beaudoux
@clarabdx

She was referring to the Second World War, and
that's what I felt in 2015 #Madeleineproject

RETWEET J'AIME
1 7

11:06 - 8 févr. 2016

clara beaudoux
@clarabdx

142

I was full of doubts about how to continue
this project, how to be fair, what position
to take

RETWEET J'AIME
1 5

11:07 - 8 févr. 2016

clara beaudoux
@clarabdx

And then I decided to go on, to cling to this
buoy of beauty Madeleine left for me

RETWEETS J'AIME
2 12

11:08 - 8 févr. 2016

clara beaudoux
@clarabdx

So here I am again to tell you about my investigation, and my presence in her absence. Off we go for another week

RETWEETS J'AIME
2 17

11:12 - 8 févr. 2016

clara beaudoux
@clarabdx

I'm not going to simply stay in the basement this time, or in the past, but let's start with all the stuff that's still down there

J'AIME
4

11:14 - 8 févr. 2016

clara beaudoux
@clarabdx

I was apprehensive about going back in there. Afraid the magic would be gone, afraid I'd been dreaming

J'AIME
6

11:15 - 8 févr. 2016

clara beaudoux
@clarabdx

But in the end… the emotion was intact.
#Madeleineproject

J'AIME
11

11:16 - 8 févr. 2016

clara beaudoux
@clarabdx

I even found things that flashed like signs
(I have to admit I've found a lot of them in this
story…) #Madeleineproject

J'AIME
5

11:17 - 8 févr. 2016

clara beaudoux
@clarabdx

And indeed, in Madeleine's cellar there is a baking
tin, for making… madeleines! #Madeleineproject

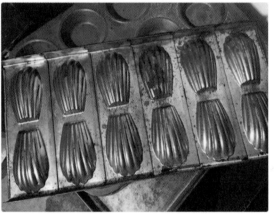

RETWEETS J'AIME
3 31

11:18 - 8 févr. 2016

There is also Proust's "Remembrance of Things Past," even if this isn't the volume where he writes about the madeleine

RETWEET J'AIME
1 12

11:22 - 8 févr. 2016

And then this article in an issue of Historia
#Madeleineproject

["MADELEINE" Secret Agent Tries to Escape]

J'AIME
10

11:23 - 8 févr. 2016

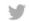

clara beaudoux
@clarabdx

In the pages of Historia, there are also ads which wouldn't really be acceptable nowadays...

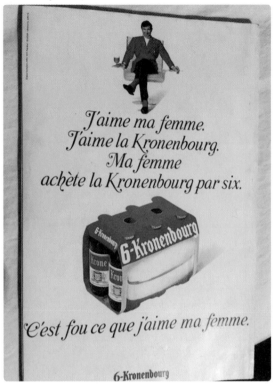

J'aime ma femme.
J'aime la Kronenbourg.
Ma femme achète la Kronenbourg par six.

C'est fou ce que j'aime ma femme.

6-Kronenbourg

[I love my wife. I love Kronenbourg beer. My wife buys Kronenbourg by the six-pack. It's crazy how I love my wife.]

clara beaudoux
@clarabdx

I really like this ad for "Razvite,"
"Shave twice as fast"
#Madeleineproject

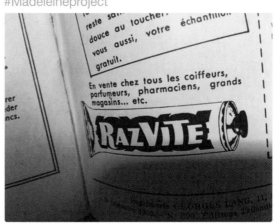

[On sale at every hairdresser's, perfumer's,
pharmacist's, department store, etc.]

RETWEET J'AIME
1 7

11:26 - 8 févr. 2016

clara beaudoux
@clarabdx

But I have to get back to that suitcase, the one I
mentioned in my last post in Season 1

clara beaudoux @clarabdx
Je m'approche, les ouvertures claquent dans le silence, et là...
#Madeleineproject

[I go over, the clasps click
open in the silence, and…
#Madeleineproject]

RETWEETS J'AIME
2 3

11:27 - 8 févr. 2016

clara beaudoux
@clarabdx

And what's inside? Two little briefcases, they must have belonged to a teacher #Madeleineproject

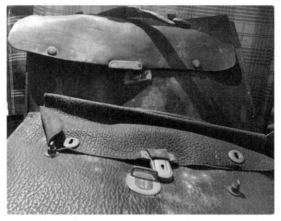

RETWEETS J'AIME
2 6

11:30 - 8 févr. 2016

clara beaudoux
@clarabdx

One of them is still full of unexplored things #Madeleineproject

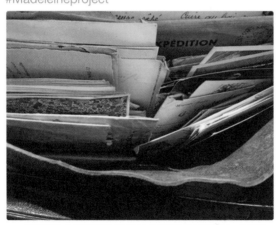

J'AIME
6

11:31 - 8 févr. 2016

clara beaudoux
@clarabdx

And a lot of photos. You don't look very happy in this one…:) #Madeleineproject

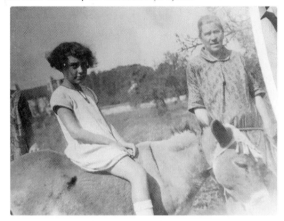

J'AIME
13

11:34 - 8 févr. 2016

clara beaudoux
@clarabdx

A few days ago I dreamed about you. And what were you dreaming about? #Madeleineproject

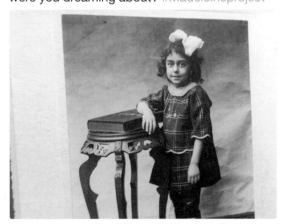

RETWEETS J'AIME
2 7

11:35 - 8 févr. 2016

 clara beaudoux
@clarabdx

You look so happy here, it's 1940; who
took the picture? Who are you smiling at?
#Madeleineproject

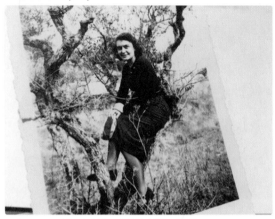

RETWEETS J'AIME
2 18

11:38 - 8 févr. 2016

 clara beaudoux
@clarabdx

And what did "happy" mean for a young
woman of 25 in 1940?
#Madeleineproject

RETWEETS J'AIME
4 12

11:38 - 8 févr. 2016

clara beaudoux
@clarabdx

There are also a few identical envelopes with negatives: should I get them developed?
#Madeleineproject

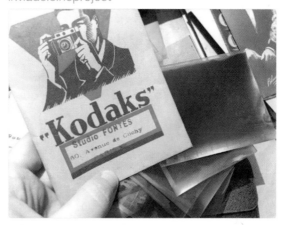

J'AIME
8

11:41 - 8 févr. 2016

DAY 1

clara beaudoux
@clarabdx

I'm discovering how you indicated which part of the photo you wanted enlarged
#Madeleineproject

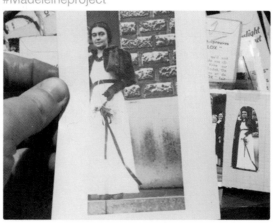

J'AIME
6

11:43 - 8 févr. 2016

clara beaudoux
@clarabdx

And in the middle of it all, Velásquez's "Las Meninas" #Madeleineproject

J'AIME
5

11:46 - 8 févr. 2016

clara beaudoux
@clarabdx

I'm trying to find Loulou in the photographs #Madeleineproject

J'AIME
9

11:47 - 8 févr. 2016

clara beaudoux
@clarabdx

In one briefcase I found a new datebook,
with some more recipes
#Madeleineproject

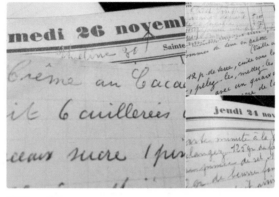

RETWEET J'AIME
1 6

11:51 - 8 févr. 2016

 153

clara beaudoux
@clarabdx

In another suitcase I had missed all these
little cards held together with the worn elastic
of a datebook #Madeleineproject

J'AIME
3

11:52 - 8 févr. 2016

clara beaudoux
@clarabdx

Like a digest of her history
#Madeleineproject

RETWEET J'AIME
1 5

11:53 - 8 févr. 2016

clara beaudoux
@clarabdx

There are ration cards, "coupons for the purchase
of shoes" in your name between
1942 and 1947 #Madeleineproject

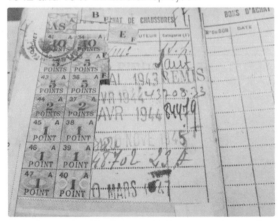

RETWEET J'AIME
1 7

11:55 - 8 févr. 2016

clara beaudoux
@clarabdx

These ration cards for bread, in 1949
#Madeleineproject

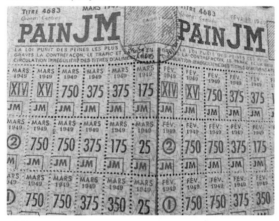

11:58 - 8 févr. 2016

clara beaudoux
@clarabdx

"Textile items," "tobacco card," memories
from my history books coming to life
#Madeleineproject

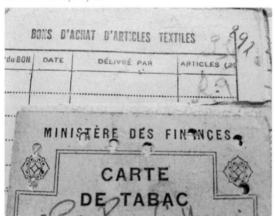

12:00 - 8 févr. 2016

Coupons for "various supplies," 1947
#Madeleineproject

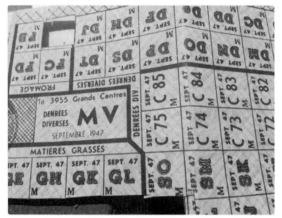

And then this voter registration card…
#Madeleineproject

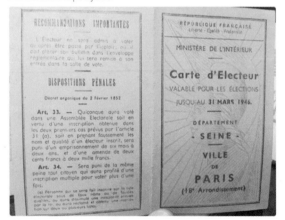

clara beaudoux
@clarabdx

This gave me a shiver: your mother Raymonde's card… from 1945, the year women obtained the right to vote!! #Madeleineproject

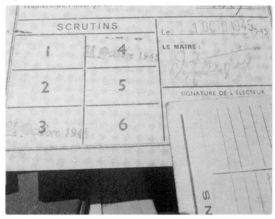

RETWEETS J'AIME
15 47

12:06 - 8 févr. 2016

clara beaudoux
@clarabdx

There is also your father's union membership card #Madeleineproject

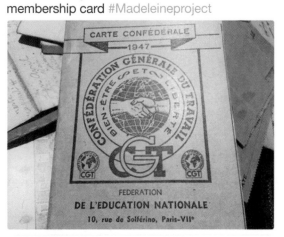

RETWEETS J'AIME
3 10

12:11 - 8 févr. 2016

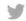

clara beaudoux
@clarabdx

I found a card he sent you in 1924, you
were 9 years old. It reminds me of my own father's
postcards

J'AIME
6

[Kisses from your Daddy, Henri]

12:12 - 8 févr. 2016

clara beaudoux
@clarabdx

There's a letter from Martial, your cousin
who died in the war, from a little boy to his
"dear uncle and aunt and cousin," 1932

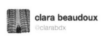

J'AIME
5

12:15 - 8 févr. 2016

clara beaudoux
@clarabdx

I also found these pins, I think they're for
your hats #Madeleineproject

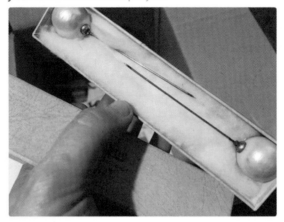

RETWEET J'AIME
1 10

12:16 - 8 févr. 2016

clara beaudoux
@clarabdx

Did you use these pins for hats like these?
#Madeleineproject

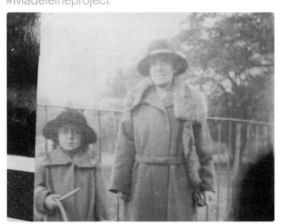

J'AIME
4

12:17 - 8 févr. 2016

And a pair of binoculars, for your travels, or maybe for the theatre… #Madeleineproject

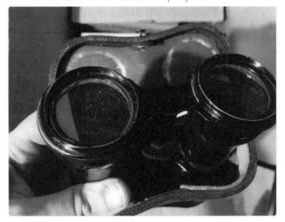

J'AIME
5

12:19 - 8 févr. 2016

SEASON 2

A more recent item, this door chain, with its brand name "rational," that was never used #Madeleineproject

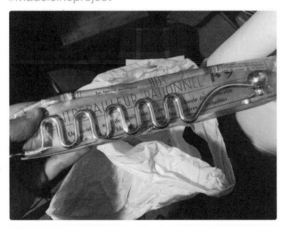

J'AIME
3

12:22 - 8 févr. 2016

clara beaudoux
@clarabdx

Then I came upon these bibs, "Be Good,"
and "Good Morning Daddy," I could give
them to my newborn nephew

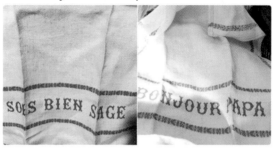

RETWEET J'AIME
1 11

12:29 - 8 févr. 2016

clara beaudoux
@clarabdx

I even get the impression there are still bits
of food on them #Madeleineproject

J'AIME
2

12:30 - 8 févr. 2016

clara beaudoux
@clarabdx

In the paint box, there's this tiny funnel: what's it for? #Madeleineproject

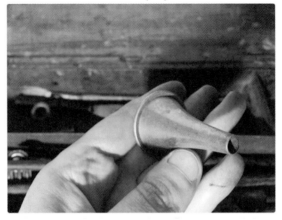

RETWEET J'AIME
1 5

12:31 - 8 févr. 2016

clara beaudoux
@clarabdx

I leafed through a few of your "literature notebooks" from 7th and 8th grade, from 1933 to 1935…! #Madeleineproject

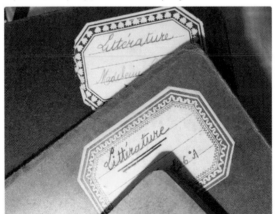

J'AIME
14

12:32 - 8 févr. 2016

clara beaudoux
@clarabdx

Baudelaire has pride of place. I found "The Albatross," a poem I had to study too
#Madeleineproject

RETWEET J'AIME
1 14

12:34 - 8 févr. 2016

clara beaudoux
@clarabdx

But at the end you wrote "THE giant wings,"
I double-checked and it should be "HIS
giant wings," the poet's wings

J'AIME
3

12:35 - 8 févr. 2016

There is also "Invitation to the Voyage,"
"damp suns in disturbed skies"
#Madeleineproject

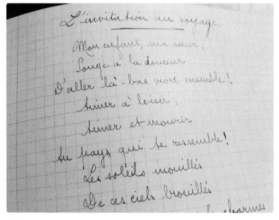

J'AIME
6

12:37 - 8 févr. 2016

And on one page of the notebook you stuck
a press clipping that cites a few lines from
the poem #Madeleineproject

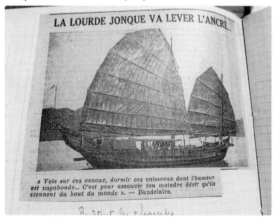

LA LOURDE JONQUE VA LEVER L'ANCRE

« Vois sur ces canaux, dormir ces vaisseaux dont l'humeur
est vagabonde... C'est pour assouvir ton moindre désir qu'ils
viennent du bout du monde ». — Baudelaire.

J'AIME
5

12:38 - 8 févr. 2016

clara beaudoux
@clarabdx

A bit further along is a little text to "future poets," I've taken this to mean us
#Madeleineproject

RETWEETS J'AIME
8 11

12:39 - 8 févr. 2016

clara beaudoux
@clarabdx

And in addition Madeleine got very good grades, 18 or 19 out of 20! #Madeleineproject

RETWEET J'AIME
1 6

12:40 - 8 févr. 2016

In the box "little things to keep," there is this tiny weight worth keeping, 20 grams #Madeleineproject

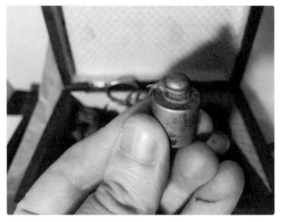

RETWEET J'AIME
1 5

12:42 - 8 févr. 2016

There are also two watches, both stopped at around six o'clock #Madeleineproject

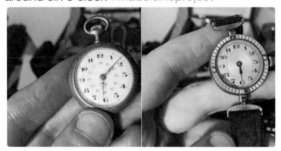

RETWEETS J'AIME
2 9

12:43 - 8 févr. 2016

clara beaudoux
@clarabdx

What was this hook for—to latch a dresser?
A cupboard? But where? In whose home?
#Madeleineproject

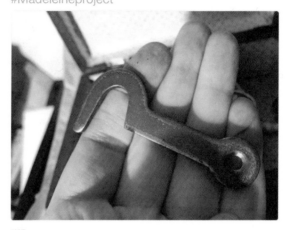

J'AIME
3

12:45 - 8 févr. 2016

clara beaudoux
@clarabdx

These little earrings (totally my style, I must
say, but would I dare to wear them?)
#Madeleineproject

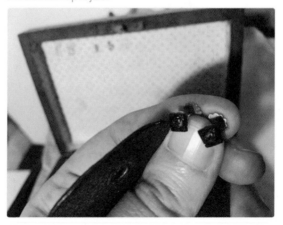

RETWEET J'AIME
1 13

12:46 - 8 févr. 2016

clara beaudoux
@clarabdx

I picked up this necklace, and it came apart
in my fingers, little pink pearls spattering
onto the concrete floor

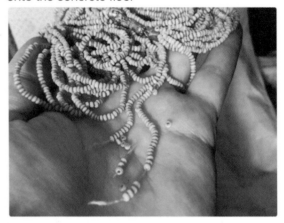

RETWEET J'AIME
1 5

12:49 - 8 févr. 2016

clara beaudoux
@clarabdx

Another necklace snapped when I picked
it up, sorry #Madeleineproject

J'AIME
9

12:50 - 8 févr. 2016

clara beaudoux
@clarabdx

In a copy of Le Monde from 1974 there's an ad
for "electronic calculators" #Madeleineproject

RETWEETS J'AIME
4 11

12:52 - 8 févr. 2016

clara beaudoux
@clarabdx

I immerse myself in a copy of "Le Matin de
Paris" from 1985, in the middle of the
"Rainbow Warrior" affair #Madeleineproject

RETWEET J'AIME
1 4

12:57 - 8 févr. 2016

clara beaudoux
@clarabdx

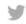

I was just about one year old, the comedian
Coluche was still alive #Madeleineproject

lessiv...

Vaste opération de police à
Grenoble : une quinzaine de
personnes ont été arrêtées, une série
d'inculpations ont été prononcées...
et ce n'est pas fini ! (p. 18)

Coluche condamné
aux « travaux forcés »

Pour avoir traité un agent de tous les
noms, le comique devra effectuer
soixante heures de travail d'intérêt
général (p. 19)

e superproduction d'Akira
—o une épopée (p. 24

[Coluche Sentenced to "Forced Labor"]

RETWEETS J'AIME
2 7

12:57 - 8 févr. 2016

clara beaudoux
@clarabdx

Italo Calvino had just died #Madeleineproject

LIVRES

ITALIE L'AUTEUR DE LA CÉLÈBRE TRILOGIE « LE VICOMTE POURFENDU », « LE
BARON PERCHÉ » ET « LE CHEVALIER INEXISTANT » S'EST ÉTEINT HIER A SIENNE

Italo Calvino : mort d'un scrutateur

[Italo Calvino: Death of a Scrutinizer]

J'AIME
4

13:00 - 8 févr. 2016

clara beaudoux
@clarabdx

Japan had taken an interest in our smart card #Madeleineproject

La carte à mémoire française séduit le Japon

● Après avoir longtemps fait de l'œil aux Japonais, la carte à mémoire française semble bien près de toucher au but : plusieurs firmes nippones pourraient l'adopter d'ici à la fin de l'année. Voilà ce que Roland Moreno, le fier papa de la carte à puce, a annoncé hier au Sicob. Les contacts sont déjà bien avancés avec les fir-

RETWEET 1 J'AIME 3

[Headline: Japan drawn to French smart card]

13:01 - 8 févr. 2016

DAY 1

clara beaudoux
@clarabdx

And there was still great enthusiasm for the Minitel computer #Madeleineproject

itachi, Mitsubishi, utres. Mais la carte à as l'intention de s'en ec Apple discute ac- nd Moreno discute ac- er un système de lec- à mémoire sur la pro- ration de micro-ordina- idée dont la réalisation tout risque de piratage de

ja, ombe Commodore est la petite bombe du Sicob. Le el ordinateur Amiga de Com-

Minitel intelligent : une commande pour Matra

● Matra Communication vient d'être retenu par la DGT pour fournir des Minitel « intelligents », baptisés M 20, qui disposent, outre les fonctions d'un Minitel classique, de fonctions téléphoniques évoluées. Il permet le stockage d'informations sur cartouche, et peut remplir certaines tâches informatiques, comme le traitement de texte ou la gestion de fichier. La commande de la DGT, qui porte sur 50 000 unités livrables à partir de 1987, tombe à pic pour Matra, qui avait été il y a quelques mois écartée du plan Informatique pour tous.

RETWEET 1 J'AIME 4

[Headline: Intelligent Minitel: Matra Sends in an Order]

13:02 - 8 févr. 2016

 clara beaudoux
@clarabdx

Steve Jobs left Apple (but would return in 1997, according to my friend in the future, Wikipedia) #Madeleineproject

> **SOCIAL**
> ## JOBS CHANGE DE JOB
> Le deuxième fondateur d'Apple démissionne quelques mois seulement après son compère Steve Wozniak. Un départ qui n'est pas vraiment une surprise
>
> En huit mois à peine, Apple aura donc perdu ses deux papas. En février dernier, Steve Wozniak, l'inventeur de l'Apple II, abandonnait le navire ; cette semaine, Steve Jobs, qui était encore chairman de l'entreprise, a annoncé à son tour sa démission. Neuf ans après sa création, la firme va définitivement changer de main.
>
> Ce départ n'est pas vraiment une surprise. Depuis plusieurs mois, la crise couvait chez Apple. En mai dernier, Jobs avait été écarté de toute responsabilité officielle. Au mois de juillet, il avait vendu un cinquième de ses actions, pour la coquette somme
>
> resserrer les boulons, n'aura pas duré. Pendant deux ans, Apple aura réussi cependant à marier la rigueur nécessaire face à une concurrence accrue et l'imagination qui a fait sa force.
>
> Dès le début de cette année pourtant, les nuages ont commencé à s'amonceler. La division Mac Intosh — le micro vedette d'Apple — affichait des résultats décevants. La campagne lancée par Jobs pour promouvoir le « Mac » auprès des entreprises se soldait par un demi-échec.
>
> Résultat : pour la première fois de son histoire, Apple enregistrait des pertes — 17 millions de dollars — et

RETWEET 1 J'AIME 13

13:03 - 8 févr. 2016

 clara beaudoux
@clarabdx

You kept wedding and birth announcements in a big envelope #Madeleineproject

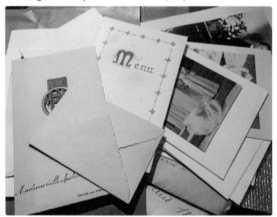

RETWEET 1 J'AIME 11

13:06 - 8 févr. 2016

clara beaudoux
@clarabdx

The menus for the receptions looked pretty yummy
#Madeleineproject

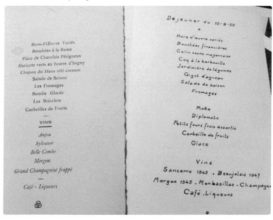

RETWEET J'AIME
1 10

13:10 - 8 févr. 2016

 clara beaudoux
@clarabdx

There are a few photos that go with them.
In 1953 you were holding a man's arm, who
was it? #Madeleineproject

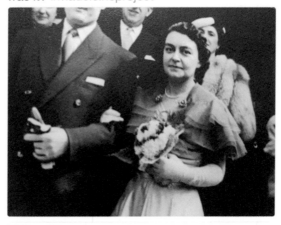

RETWEET J'AIME
1 12

13:12 - 8 févr. 2016

 clara beaudoux
@clarabdx

In fact I went down to the cellar more than once, particularly last week, to put the finishing touches to this season #Madeleineproject

RETWEETS J'AIME
2 5

13:14 - 8 févr. 2016

 clara beaudoux
@clarabdx

And I had an unpleasant surprise: a leak from one of those big pipes running along the gray walls #Madeleineproject

J'AIME
3

13:15 - 8 févr. 2016

 clara beaudoux
@clarabdx

There was a strong smell of mold, but I figured that even mold could be pretty #Madeleineproject

J'AIME
6

13:17 - 8 févr. 2016

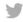

clara beaudoux
@clarabdx

Fortunately the damage was minimal. It was the bedsheets that got wet, and thankfully they acted as a sponge #Madeleineproject

J'AIME
4

13:17 - 8 févr. 2016

clara beaudoux
@clarabdx

Because Madeleine kept a number of sheets down there, embroidered with the family initials #Madeleineproject

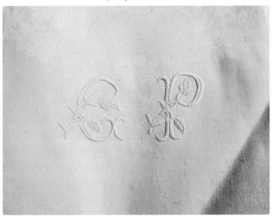

RETWEET J'AIME
1 8

13:19 - 8 févr. 2016

clara beaudoux
@clarabdx

There was even this little note pinned to a
piece of fabric #Madeleineproject

5

[top sheet, piece to be
added, lengthwise]

13:20 - 8 févr. 2016

clara beaudoux
@clarabdx

And the fur coat got soaked, the red lining
ran... #Madeleineproject

5

13:21 - 8 févr. 2016

clara beaudoux
@clarabdx

For a moment I was completely enthralled by the soaked cardboard box #Madeleineproject

J'AIME
5

13:22 - 8 févr. 2016

DAY 1

177

clara beaudoux
@clarabdx

So the plumber came. Well, he had no idea he was going into Madeleine's cellar…

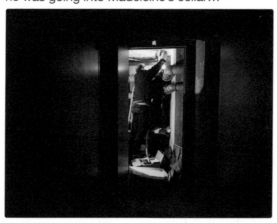

J'AIME
4

13:23 - 8 févr. 2016

 clara beaudoux
@clarabdx

I saw this leak as a sign telling me to "stop everything!" A neighbor told me it meant, rather, "Hurry up and get on with it!"

J'AIME
20

13:25 - 8 févr. 2016

 clara beaudoux
@clarabdx

Tomorrow I'll start telling you about my meetings with Madeleine's neighbors, some of whom are still mine, too

RETWEET J'AIME
1 27

13:25 - 8 févr. 2016

 clara beaudoux
@clarabdx

More tomorrow #Madeleineproject
madeleineproject.fr

J'AIME
21

13:26 - 8 févr. 2016

 clara beaudoux
@clarabdx

It's Sunday, I'm due to meet Marc and
Sylvain at their place, they've got a star on
their door, Christmas is coming

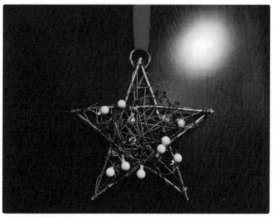

RETWEET J'AIME
1 3

11:09 - 9 févr. 2016

clara beaudoux
@clarabdx

They live on my floor, our floor, they looked after Madeleine, particularly when other neighbors had moved away #Madeleineproject

J'AIME
2

11:10 - 9 févr. 2016

clara beaudoux
@clarabdx

I had run into Marc during Season 1, on my way down to the cellar, he said he "had seen," "had realized it was her"

J'AIME
3

11:11 - 9 févr. 2016

clara beaudoux
@clarabdx

I remember pausing, standing there, even though the elevator had come. As if I were waiting for what he would say next #Madeleineproject

J'AIME
2

11:12 - 9 févr. 2016

clara beaudoux
@clarabdx

He found it thoughtful. Gosh #Madeleineproject

J'AIME
5

11:12 - 9 févr. 2016

clara beaudoux
@clarabdx

He said it all brought her back to life. They hadn't known her "before." Before what? "Before she was an old lady, 90 years old."

J'AIME
4

11:13 - 9 févr. 2016

clara beaudoux
@clarabdx

How did they remember her? "A cheerful old lady," said Marc, "she had firmly held beliefs, and a sense of humor, too"

J'AIME
8

11:14 - 9 févr. 2016

clara beaudoux
@clarabdx

181

"She liked to say silly things from time to time," added Sylvain, she had a "twinkle in her eye"
#Madeleineproject

RETWEET J'AIME
1 4

11:16 - 9 févr. 2016

clara beaudoux
@clarabdx

He remembers an old lady who was "a bit mischievous," or who must have been at one time, before her body began to fail her
#Madeleineproject

J'AIME
6

11:17 - 9 févr. 2016

 clara beaudoux
@clarabdx

He was glad to see her smiles in Season 1
#Madeleineproject

 clara beaudoux @clarabdx
Comme tu avais l'air rigolote, là, Madeleine #Madeleineproject

RETWEETS J'AIME
2 3

[You look really sweet and funny in this one,
Madeleine #Madeleineproject]

11:17 - 9 févr. 2016

 clara beaudoux
@clarabdx

They described her as a "kind, adorable" woman.
And I wonder what I would have done if I'd found
out she was nasty… #Madeleineproject

J'AIME
7

11:18 - 9 févr. 2016

 clara beaudoux
@clarabdx

She was also "very unobtrusive," they didn't see
her often, but they met her at the neighborhood
gatherings, she always came #Madeleineproject

J'AIME
4

11:20 - 9 févr. 2016

 clara beaudoux
@clarabdx

(and here I am, I've never been to any of them)

J'AIME
5

11:20 - 9 févr. 2016

clara beaudoux
@clarabdx

"Since she didn't feel like cooking anymore, or couldn't, she always ordered a large pie or quiche from the boulangerie on the corner"

J'AIME
2

11:21 - 9 févr. 2016

clara beaudoux
@clarabdx

Did you go to the same boulangerie as me, Madeleine?

RETWEET J'AIME
1 2

11:21 - 9 févr. 2016

clara beaudoux
@clarabdx

183

Madeleine managed thanks to neighbors and a cleaning lady, for the shopping and for her mail #Madeleineproject

RETWEET J'AIME
1 2

11:23 - 9 févr. 2016

clara beaudoux
@clarabdx

And thanks to her godson, who came from time to time to take her out to lunch #Madeleineproject

RETWEET J'AIME
1 2

11:24 - 9 févr. 2016

 clara beaudoux
@clarabdx

What sort of mail did she get? Not a lot, a few bills, but "she really looked forward to her Paris Match"

RETWEET · J'AIME
1 · 3

11:25 · 9 févr. 2016

 clara beaudoux
@clarabdx

Of course, I'd already found a Paris Match in the cellar

 clara beaudoux @clarabdx

Et tout d'un coup, au milieu de tous ces bouquins, en bordure de carton, paf... #Madeleineproject

RETWEETS · J'AIME
2 · 3

11:27 · 9 févr. 2016

[Then all of a sudden, in the middle of all these books, on one side of the box, look who's here…
#Madeleineproject]

 clara beaudoux
@clarabdx

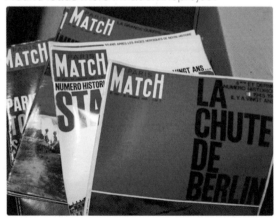

I found loads more #Madeleineproject

[Headline: The Fall of Berlin]

J'AIME
2

11:28 · 9 févr. 2016

 clara beaudoux
@clarabdx

In particular the issue with man's first steps on the moon, I'd bought it myself not long ago at a flea market

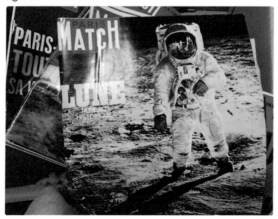

RETWEET J'AIME
1 2

11:30 - 9 févr. 2016

DAY 2

 clara beaudoux
@clarabdx

"In a blast of fire, a new era has begun"
#Madeleineproject

J'AIME
3

11:31 - 9 févr. 2016

 clara beaudoux
@clarabdx

There's a page about the future, "A Honeymoon in the Year 2000" #Madeleineproject

RETWEETS J'AIME
5 10

11:33 - 9 févr. 2016

 clara beaudoux
@clarabdx

The year 2000, as seen from 1969: a future that is now my past, seen from a past that was your present... Hmm

J'AIME
12

11:35 - 9 févr. 2016

And in that issue you put a few other clippings about the space race! You amaze me

#Madeleineproject

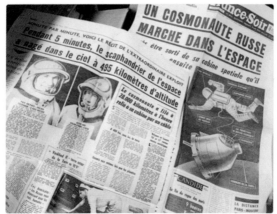

RETWEETS 2 J'AIME 6

11:38 - 9 févr. 2016

[Headlines: "A Russian Cosmonaut Walks in Space"
"The space diver swam in the sky for 5 minutes at an
altitude of 495 kilometers"]

DAY 2

That reminds me, this has also happened since Season 1, did you ever hear this song, Madeleine?

https://www.youtube.com/watch?v=iYYRH4apXDo

#Madeleineproject

David Bowie – Space Oddity [OFFICIAL VIDEO]
Official video for David Bowie - Space Oddity. David Bowie (Five Years 1969 – 1973) is available as 2 beautifully packaged Limited Edition box sets; on 180g ...
youtube.com

J'AIME 2

11:39 - 9 févr. 2016

clara beaudoux
@clarabdx

"Toward the end she was a bit deaf, when I brought up the mail sometimes I had to call her on the phone, she couldn't hear the doorbell"

RETWEET J'AIME
1 2

11:43 - 9 févr. 2016

clara beaudoux
@clarabdx

That doorbell is still my doorbell, here it is
https://soundcloud.com/madeleine-project
#Madeleineproject

#Madeleineproject Sonnette
Listen to #Madeleineproject Sonnette by Madeleine project #np on #SoundCloud
soundcloud

RETWEETS J'AIME
2 8

11:47 - 9 févr. 2016

clara beaudoux
@clarabdx

Toward the end "she was a fairly stout little lady, who had some trouble getting around," "she was a little porcelain figurine," Marc said

RETWEET J'AIME
1 3

11:49 - 9 févr. 2016

 clara beaudoux
@clarabdx

"But there was a period when she still went to the hairdresser's, we saw her, this little lady trotting along the street"

RETWEET 1 J'AIME 2

11:49 - 9 févr. 2016

 clara beaudoux
@clarabdx

"She'd come back with her hair all curly, all spruced up" "a sort of beehive" "she still dyed it, dark blond or light chestnut"

RETWEET 1 J'AIME 4

11:50 - 9 févr. 2016

clara beaudoux
@clarabdx

189

They told me she went to a hairdresser's a bit further down the street, there's a luthier there now
#Madeleineproject

11:50 - 9 févr. 2016

clara beaudoux
@clarabdx

So I went to see the luthier. No, he tells me,
the hairdresser was next door
#Madeleineproject

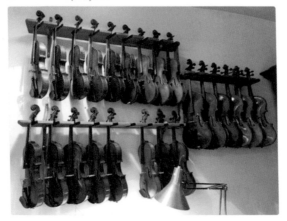

J'AIME
4

11:52 - 9 févr. 2016

clara beaudoux
@clarabdx

The hairdresser's no longer exists, but the
luthier knows some violinists whose babysitter was
the hairdresser's daughter

RETWEET J'AIME
1 4

11:54 - 9 févr. 2016

clara beaudoux
@clarabdx

But at the same time, what's the point in talking to Madeleine's hairdresser? I really don't know; I'm groping around in the dark

RETWEET J'AIME
1 6

11:55 - 9 févr. 2016

clara beaudoux
@clarabdx

In the end the hairdresser texted me that she didn't remember Madeleine, what a pity...
#Madeleineproject

RETWEET J'AIME
1 3

11:55 - 9 févr. 2016

clara beaudoux
@clarabdx

And how did she used to dress? "She always wore a dress, no trousers" "for a long time she went on making a special effort"

RETWEET J'AIME
1 3

11:56 - 9 févr. 2016

clara beaudoux
@clarabdx

"She wanted to look her best" said Sylvain and Marc #Madeleineproject

RETWEET J'AIME
1 2

11:57 - 9 févr. 2016

 clara beaudoux
@clarabdx

Several neighbors sent me examples
damart.fr/static//15/13/… mfs1.cdnsw.com/
fs/Veste_hiver… bleu-bonheur.fr/media/
catalog/… media.gettyimages.com/photos/
picture…

J'AIME
4

12:00 - 9 févr. 2016

 clara beaudoux
@clarabdx

Madeleine didn't tell them much about her life, but
once she did mention Aix, where she lived with her
parents during the war

RETWEET J'AIME
1 3

12:02 - 9 févr. 2016

clara beaudoux
@clarabdx

I found a map of Aix in the cellar
#Madeleineproject

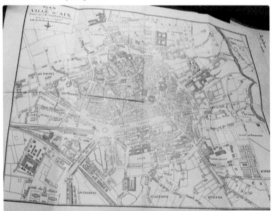

J'AIME
2

12:03 - 9 févr. 2016

clara beaudoux
@clarabdx

"She brought me some calisson candies one time"
said Sylvain, because she was touched
that he'd sent her a postcard from Polynesia

RETWEET J'AIME
1 5

12:05 - 9 févr. 2016

clara beaudoux
@clarabdx

Speaking of postcards, I was very touched by
@ilesttropgentil 's gesture

J'AIME
1

12:07 - 9 févr. 2016

clara beaudoux
@clarabdx

He sent me pictures of Cayeux where
Madeleine went on vacation in 1925 and 1931

eric @ilesttropgentil
#Madeleineproject Cayeux sur mer Vacances 1925

J'AIME
4

12:07 - 9 févr. 2016

clara beaudoux
@clarabdx

Here are her trips again, and don't hesitate
to send me digital postcards if ever you go
to any of these places!

 clara beaudoux @clarabdx

Dans le carton papeterie, il y aussi la liste de tes vacances. J'ai
l'impression que tu me laisses des indices

RETWEETS J'AIME
3 2

12:09 - 9 févr. 2016

*[In the stationery box there is also
a list with all your trips. It's as
if you're leaving me clues]*

clara beaudoux
@clarabdx

Actually I found another list, with more trips
#Madeleineproject

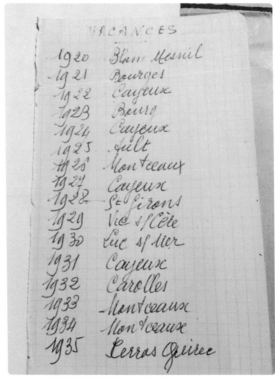

RETWEET J'AIME
1 6

12:09 - 9 févr. 2016

 clara beaudoux
@clarabdx

Madeleine had to walk with a cane "but she never complained," "except at the very end" said her neighbors #Madeleineproject

RETWEET 1 J'AIME 5

12:12 - 9 févr. 2016

 clara beaudoux
@clarabdx

"At the end of her life, she was very afraid of dying," "that she might die during the night," said Marc soundcloud.com/madeleine-proj…

 #Madeleineproject "Elle était encore vraiment dans la vie" …
Listen to #Madeleineproject "Elle était encore vraiment dans la vie" Marc by Madeleine project #np on #SoundCloud
soundcloud

RETWEET 1 J'AIME 9

12:16 - 9 févr. 2016

 clara beaudoux
@clarabdx

"It shows she really was very much alive" "and she felt she hadn't yet done everything she had to do"

RETWEET 1 J'AIME 4

12:19 - 9 févr. 2016

 clara beaudoux
@clarabdx

"I just have one regret, that I met her too late," said Sylvain, describing how they spent time together, "we left early, got home late"

RETWEETS J'AIME
2 6

12:20 - 9 févr. 2016

 clara beaudoux
@clarabdx

"In any case I'm glad to have known her" added Sylvain #Madeleineproject soundcloud.com/madeleine-proj…

 #Madeleineproject "Je suis content de l'avoir croisée" Sylvain
Listen to #Madeleineproject "Je suis content de l'avoir croisée" Sylvain by Madeleine project #np on #SoundCloud
soundcloud

RETWEETS J'AIME
3 5

12:24 - 9 févr. 2016

 clara beaudoux
@clarabdx

Marc regrets he "didn't talk to her more, because now we realize there were lots of sides to her life, and we missed them"

RETWEET J'AIME
1 3

12:26 - 9 févr. 2016

clara beaudoux
@clarabdx

They wonder, for example, what she did during the early years of her retirement #Madeleineproject

RETWEET J'AIME
1 2

12:27 - 9 févr. 2016

clara beaudoux
@clarabdx

Sylvain remembers she used to say "Do you realize
I've spent more time retired than I did working, isn't
that something" and she'd laugh

RETWEET J'AIME
1 7

12:28 - 9 févr. 2016

 clara beaudoux
@clarabdx

When they rang her doorbell "she existed for
someone" "it's awful to realize that," that they were
"the little event of her day"

RETWEETS J'AIME
2 9

12:30 - 9 févr. 2016

 clara beaudoux
@clarabdx

Marc and Sylvain gave me the contact info for
the neighbors who lived just next door to me (to
you) for 15 years

RETWEET J'AIME
1 2

12:31 - 9 févr. 2016

 clara beaudoux
@clarabdx

I also asked Marc and Sylvain about that
second name on the mailbox…
#Madeleineproject

RETWEET J'AIME
1 1

12:31 - 9 févr. 2016

clara beaudoux
@clarabdx

They mentioned a "daughter-in-law" but how could she have a "daughter-in-law"???
#Madeleineproject

12:32 - 9 févr. 2016

clara beaudoux
@clarabdx

After all this I have begun to imagine you ever more clearly, I can hear your slippers on the floorboards of the apartment
#Madeleineproject

12:32 - 9 févr. 2016

clara beaudoux
@clarabdx

When I drink some tea by the coffee table, or work at my desk, when the place is a mess, I think of you #Madeleineproject

12:33 - 9 févr. 2016

clara beaudoux
@clarabdx

More tomorrow: we'll meet Eveline and Robert, who looked after Madeleine more than anyone
#Madeleineproject
madeleineproject.fr

12:34 - 9 févr. 2016

 clara beaudoux
@clarabdx

 199

Before anything else I have to tell you this,
it's crazy, I've been so eager to tell you
#Madeleineproject

J'AIME
2

11:00 - 10 févr. 2016

 clara beaudoux
@clarabdx

Yesterday I went down to the cellar several
times to photograph the recipes people had asked
me for #Madeleineproject

 clara beaudoux @clarabdx
.@Stefany_cm_h super idée :) voici trois recettes au choix !
#Madeleineproject

J'AIME
4

11:01 - 10 févr. 2016

[@Stefany_cm_h great idea :) here
are three recipes for you to choose from!
#Madeleineproject]

 clara beaudoux
@clarabdx

When I went looking for the "quick frying pan pie" (for @Deedo_75 thanks :), I knew where the recipe was #Madeleineproject

11:03 - 10 févr. 2016

 clara beaudoux
@clarabdx

In a notebook in a briefcase in a suitcase on the right-hand side of the shelf on the left #Madeleineproject

11:04 - 10 févr. 2016

 clara beaudoux
@clarabdx

But when I took out the notebook, something fell from the briefcase, and it was as if it had come out all on its own:

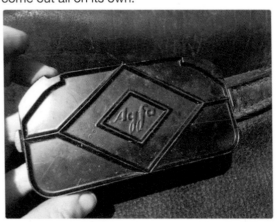

J'AIME
3

11:05 - 10 févr. 2016

clara beaudoux
@clarabdx

I didn't immediately get it…
#Madeleineproject

J'AIME
3

11:06 - 10 févr. 2016

clara beaudoux
@clarabdx

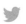

And then my heart began to beat very fast.
Yes, go ahead, for goodness sake, I opened it, and
found a film!!? #Madeleineproject

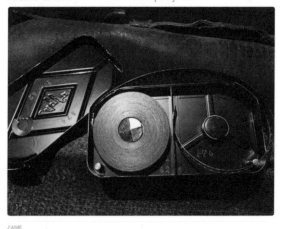

J'AIME
14

11:08 - 10 févr. 2016

 clara beaudoux
@clarabdx
 Suivre

According to Google it's a film for an Agfa
Movex 8? How can I watch it? I need help!
Thanks :)
google.fr/search?q=Agfa+...

RETWEETS J'AIME
5 2

11:09 - 10 févr. 2016

 clara beaudoux
@clarabdx

Well, I'll keep you posted regarding the film!
Back to the neighbors.
#Madeleineproject

J'AIME
3

11:17 - 10 févr. 2016

 clara beaudoux
@clarabdx

It's Wednesday, I'm taking the 1:50 p.m. train from
the Gare Saint-Lazare, it's overcast #Madeleineproject

11:18 - 10 févr. 2016

 clara beaudoux
@clarabdx

I'm on my way to see Robert and Eveline, in the
Hauts-de-Seine west of Paris, the neighbors
who took care of Madeleine more than anyone
#Madeleineproject

J'AIME
4

11:19 - 10 févr. 2016

clara beaudoux
@clarabdx

For fifteen years they lived right next door
#Madeleineproject

11:19 - 10 févr. 2016

clara beaudoux
@clarabdx

I was early so I walked around, I went past
a dry cleaner's, do you really take wedding gowns
to a dry cleaner's?

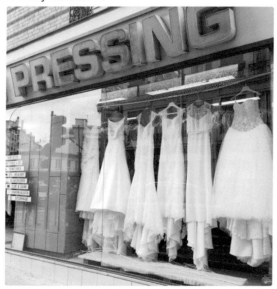

203

J'AIME
9

11:21 - 10 févr. 2016

clara beaudoux
@clarabdx

As I walked to their place I wondered if you
had ever come this way, too
#Madeleineproject

11:21 - 10 févr. 2016

 clara beaudoux
@clarabdx

And I thought it was sort of crazy of me to think about you so much, since you didn't even know I exist #Madeleineproject

J'AIME
5

11:22 - 10 févr. 2016

 clara beaudoux
@clarabdx

At their place: a green velvet sofa, like the one my aunt has, and a fine view from the window of La Défense #Madeleineproject

11:23 - 10 févr. 2016

 clara beaudoux
@clarabdx

How do you remember her? "I had a great deal of respect for her" said Robert #Madeleineproject

 #Madeleineproject "Quelqu'un que j'ai très estimé" Robert
Listen to #Madeleineproject "Quelqu'un que j'ai très estimé" Robert by Madeleine project #np on #SoundCloud
soundcloud

RETWEET J'AIME
1 6

11:25 - 10 févr. 2016

 clara beaudoux
@clarabdx

Madeleine did "a lot of crossword puzzles" #Madeleineproject

11:27 - 10 févr. 2016

clara beaudoux
@clarabdx

"And like me she was very fond of Michel Laclos"
laughed Robert, handing me a puzzle book
#Madeleineproject

J'AIME
4

11:28 - 10 févr. 2016

clara beaudoux
@clarabdx

It was an opportunity for me to discover this
crossword compiler (and to look him up at the
same time): fr.wikipedia.org/wiki/Michel_La...

J'AIME
3

11:29 - 10 févr. 2016

 clara beaudoux
@clarabdx

"She liked to record things, too, she had a little recorder with cassettes, and she used it mainly for documentaries"

J'AIME
3

11:30 - 10 févr. 2016

 clara beaudoux
@clarabdx

When he said that for a second I thought Madeleine made documentaries (the way I do, sort of) but of course she didn't (calm down Clara)

J'AIME
4

11:30 - 10 févr. 2016

 clara beaudoux
@clarabdx

In fact, Madeleine just recorded off the TV with her VCR! But it's still nice to know she liked documentaries

J'AIME
3

11:32 - 10 févr. 2016

 clara beaudoux
@clarabdx

Eveline remembers Madeleine as a very open and modern person, in particular because...(!!) soundcloud.com/madeleine-proj...

#Madeleineproject Eveline "Son grand regret, ne pas savoir...
Listen to #Madeleineproject Eveline "Son grand regret, ne pas savoir manipuler un ordinateur" by Madeleine project #np on #SoundCloud
soundcloud

RETWEET J'AIME
1 7

11:35 - 10 févr. 2016

clara beaudoux
@clarabdx

Madeleine "regretted not being computer literate, more than anything" said Eveline
#Madeleineproject

RETWEET J'AIME
1 5

11:38 - 10 févr. 2016

clara beaudoux
@clarabdx

"One day I tried to show her but she eventually said 'oh, it's too complicated,' but she really wanted to, she wanted to know"

J'AIME
6

11:38 - 10 févr. 2016

clara beaudoux
@clarabdx

(With the hope that these little snapshots of your life on Twitter will go some way toward fulfilling your digital yearnings)

J'AIME
7

11:40 - 10 févr. 2016

clara beaudoux
@clarabdx

Robert recalled that Madeleine told him one day she ought to go through the things in the cellar
#Madeleineproject

J'AIME
4

11:41 - 10 févr. 2016

"She knew there was a lot of junk down
there, 'all the stuff I kept,' she said"
#Madeleineproject

J'AIME
2

11:42 - 10 févr. 2016

 clara beaudoux
@clarabdx

Would you have kept this thing, for example?
#Madeleineproject

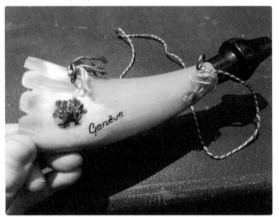

11:43 - 10 févr. 2016

<div style="text-align:right">SEASON 2</div>

 clara beaudoux
@clarabdx

But after all, as Robert said, aren't we all like that?
He himself, for a start...

11:46 - 10 févr. 2016

clara beaudoux
@clarabdx

He dreamed of a castle where he could "keep everything," "to my wife's dismay," he joked, but that's another story

J'AIME
5

11:47 - 10 févr. 2016

clara beaudoux
@clarabdx

Robert also told me that every Thursday evening Madeleine "stuck a little Post-it on their door, with her list" #Madeleineproject

11:48 - 10 févr. 2016

clara beaudoux
@clarabdx

Because every Friday morning Robert went to the fish market, a few streets over #Madeleineproject

209

11:49 - 10 févr. 2016

clara beaudoux
@clarabdx

"Madeleine loved fish," she wrote "crab's claws, skate." Robert knew he had some leeway, he knew what she liked

11:50 - 10 févr. 2016

clara beaudoux
@clarabdx

"Unfortunately she had heart trouble, and she
was quite plump" and "she really liked to eat"
#Madeleineproject

11:51 - 10 févr. 2016

 clara beaudoux
@clarabdx

What she loved more than anything was a nice
John Dory fish #Madeleineproject

11:52 - 10 févr. 2016

 clara beaudoux
@clarabdx

"But I didn't get it often because for one
person it's huge. When they had little ones
I'd bring one back for her."

11:53 - 10 févr. 2016

210

clara beaudoux
@clarabdx

I went to the fishmonger's last Friday,
and he did indeed have John Dory

#Madeleineproject

J'AIME
2

11:54 - 10 févr. 2016

clara beaudoux
@clarabdx

But I didn't buy any either, it was too much
for me on my own #Madeleineproject soundcloud.
com/madeleine-proj...

 #Madeleineproject Poissonnier
Listen to #Madeleineproject Poissonnier by Madeleine project
#np on #SoundCloud
soundcloud

RETWEET J'AIME
1 3

11:56 - 10 févr. 2016

clara beaudoux
@clarabdx

I told the fishmonger my story, and he said, "yes, Madeleine. That rings a bell," but I think he said it to be kind

J'AIME
2

11:58 - 10 févr. 2016

clara beaudoux
@clarabdx

"Sometimes we invited her over for lunch, because she was pretty much on her own," continued Eveline #Madeleineproject

J'AIME
2

12:00 - 10 févr. 2016

clara beaudoux
@clarabdx

"She had a step-daughter, her husband's daughter," she continued #Madeleineproject

J'AIME
3

12:01 - 10 févr. 2016

clara beaudoux
@clarabdx

Hey, wait a minute: Madeleine was married? Listen to this important moment where I question her: #soundcloud.com/madeleine-proj… #Madeleineproject

#Madeleineproject Question mariage
Listen to #Madeleineproject Question mariage by Madeleine project #np on #SoundCloud
soundcloud

RETWEET J'AIME
1 12

12:03 - 10 févr. 2016

 clara beaudoux
@clarabdx

They don't really agree, but they remember she used to refer to a "husband," but they never knew him #Madeleineproject

J'AIME
3

12:06 - 10 févr. 2016

 clara beaudoux
@clarabdx

"It's times like this, after the fact, that you think, 'maybe I could have spoken to her a bit more'" says Robert #Madeleineproject

RETWEET J'AIME
1 4

12:06 - 10 févr. 2016

 clara beaudoux
@clarabdx
 213

When Madeleine came for lunch, she often brought a gift, "she didn't like to come empty-handed" #Madeleineproject

J'AIME
4

12:08 - 10 févr. 2016

 clara beaudoux
@clarabdx

And off we go, searching Eveline and Robert's apartment for Madeleine's presents #Madeleineproject

J'AIME
3

12:08 - 10 févr. 2016

clara beaudoux
@clarabdx

They showed me this book, and these dish
towels, and then these fish knives and forks
#Madeleineproject

J'AIME
5

12:11 - 10 févr. 2016

clara beaudoux
@clarabdx

Then they hunted for a long time on the bookshelf
until they found these two books
she had given them

RETWEET J'AIME
1 7

12:12 - 10 févr. 2016

clara beaudoux
@clarabdx

Thanks to Eveline and Robert I found out
how you had arranged my/your apartment
#Madeleineproject

J'AIME
3

12:16 - 10 févr. 2016

clara beaudoux
@clarabdx

We made a little drawing, your bed was in the
same place as mine #Madeleineproject

RETWEET J'AIME
1 4

12:17 - 10 févr. 2016

clara beaudoux
@clarabdx

At this very moment, while I'm typing at my desk, I'm right where you had your television #Madeleineproject

RETWEET 1 J'AIME 3

12:18 - 10 févr. 2016

clara beaudoux
@clarabdx

They also told me how she came asking for recommendations for restaurants in the neighborhood for her Dutch friends #Madeleineproject

J'AIME 3

12:21 - 10 févr. 2016

clara beaudoux
@clarabdx

She would water their plants when they were away, and Eveline would take her some crêpes on a little plate #Madeleineproject

J'AIME 3

12:22 - 10 févr. 2016

clara beaudoux
@clarabdx

Madeleine was sorry she had "never known anything besides teaching" "had never moved in other circles" #Madeleineproject

RETWEET 1 J'AIME 6

12:22 - 10 févr. 2016

clara beaudoux
@clarabdx

We talked about the photograph with two couples picnicking on the grass, which had pride of place in her living room #Madeleineproject

J'AIME
4

12:23 - 10 févr. 2016

clara beaudoux
@clarabdx

About an apartment in Cannes, which she eventually sold #Madeleineproject

J'AIME
3

12:23 - 10 févr. 2016

clara beaudoux
@clarabdx

After that she'd go and "spend a month of vacation at a thermal spa in Bagnoles-de-l'Orne, it's in the Orne region"

J'AIME
3

12:24 - 10 févr. 2016

217

clara beaudoux
@clarabdx

In the summer of 2011 when she came home from vacation Eveline and Robert were gone. They had moved, naturally they had let her know

J'AIME
3

12:26 - 10 févr. 2016

clara beaudoux
@clarabdx

But they thought it must have been a blow for her… #Madeleineproject

J'AIME
3

12:27 - 10 févr. 2016

clara beaudoux
@clarabdx

"She counted on us a great deal" "since she had a heart problem, and her studio was adjacent to our bedroom, we had an arrangement"

J'AIME
3

12:28 - 10 févr. 2016

clara beaudoux
@clarabdx

She told them "If one day I don't feel well in the middle of the night I'll bang on the wall with my cane, if you don't mind" #Madeleineproject

J'AIME
3

12:29 - 10 févr. 2016

clara beaudoux
@clarabdx

"And she took her key out of the lock every night, so that we could get into the apartment" #Madeleineproject

J'AIME
3

12:29 - 10 févr. 2016

clara beaudoux
@clarabdx

Madeleine died a few months later, in early 2012 #Madeleineproject

RETWEET J'AIME
1 3

12:30 - 10 févr. 2016

clara beaudoux
@clarabdx

(In other words just over a year before I moved in)

J'AIME
2

12:31 - 10 févr. 2016

DAY 3

clara beaudoux
@clarabdx

When I went to see Robert and Eveline I thought I'd find out where Madeleine was buried so I could go to see her grave #Madeleineproject

219

J'AIME
4

12:34 - 10 févr. 2016

clara beaudoux
@clarabdx

They told me she'd been cremated, at Père-Lachaise Cemetery, but they don't know where her ashes are #Madeleineproject

J'AIME
6

12:35 - 10 févr. 2016

clara beaudoux
@clarabdx

And this starts Robert thinking about his own
life, he's sorry he didn't question his parents more
about their childhood

RETWEET J'AIME
1 5

12:36 - 10 févr. 2016

clara beaudoux
@clarabdx

"When you're young, you think they'll live forever"
"And I should have done what you're doing, written
it all down!" #Madeleineproject

RETWEETS J'AIME
2 7

12:37 - 10 févr. 2016

clara beaudoux
@clarabdx

More tomorrow #Madeleineproject madeleineproject.fr

RETWEET J'AIME
1 13

12:37 - 10 févr. 2016

 clara beaudoux
@clarabdx

For a start, thanks to Anne-Laure (and to others in future), because Madeleine's recipes have come alive again <3

 Anne-Laure @BazardesReves

Ce soir c'est on aura une pensée pour Madeleine en goûtant son "biscuit maison" 😊 @clarabdx #Madeleineproject

221

J'AIME
14

11:12 - 11 févr. 2016

[Anne-Laure @BazardesReves
Tonight we'll be thinking of Madeleine when
we try her "home-made sponge cake" :)
@clarabdx #Madeleineproject]

 clara beaudoux
@clarabdx

Thanks to Pauline C. as well, who sent me via Facebook these pictures of St-Girons, Madeleine's vacation in 1928

RETWEET J'AIME
1 2

11:14 - 11 févr. 2016

clara beaudoux
@clarabdx

She even sent "a real postcard from the turn of the century, taken 15 years before Madeleine was born." Thanks :)

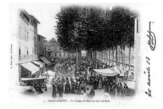

J'AIME
3

11:15 - 11 févr. 2016

clara beaudoux
@clarabdx

In the cellar I found an envelope, "St-Girons, 1928," you were 10 years old, and there's this bridge #Madeleineproject

222

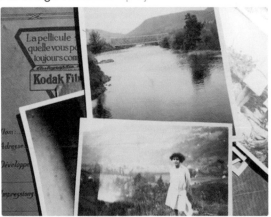

RETWEET J'AIME
1 2

11:17 - 11 févr. 2016

clara beaudoux
@clarabdx

Let's get back to the people who knew Madeleine
#Madeleineproject

J'AIME
2

11:18 - 11 févr. 2016

 clara beaudoux
@clarabdx

One day I went to meet Brigitte, a neighbor
from the 4th floor. Through the walls of the building
I often hear her son playing the piano

J'AIME
2

11:19 - 11 févr. 2016

 clara beaudoux
@clarabdx

Musical moment: at the bottom of a suitcase
I found a tuning fork. So I struck the note of A
#Madeleineproject

RETWEET J'AIME
1 6

11:21 - 11 févr. 2016

 clara beaudoux
@clarabdx

Marc and Sylvain were the ones who first told Brigitte about the #Madeleineproject, without telling her who it was about

11:22 - 11 févr. 2016

 clara beaudoux
@clarabdx

Brigitte began to read Season 1 and "after two or three tweets, I said to myself: but this is our Madeleine!" #Madeleineproject

J'AIME
4

11:23 - 11 févr. 2016

 clara beaudoux
@clarabdx

"That's the way it was, that's her all over" "as if she were guiding you, as if there were a vital lead" #Madeleineproject

J'AIME
9

11:24 - 11 févr. 2016

 clara beaudoux
@clarabdx

(How to hold in my emotion) #Madeleineproject

J'AIME
10

11:25 - 11 févr. 2016

 clara beaudoux
@clarabdx

"It's as if she had left a testimony, as if she wanted to leave her whole life behind her"
#Madeleineproject

J'AIME
8

11:26 - 11 févr. 2016

 clara beaudoux
@clarabdx

"It brings her to life, it also gives her the recognition she deserves" "she was a very fine person" "everyone adored her"

RETWEETS J'AIME
2 11

11:27 - 11 févr. 2016

DAY 4

 clara beaudoux
@clarabdx

225

"She was always very attentive toward others, always," always, said Brigitte
#Madeleineproject

J'AIME
3

11:28 - 11 févr. 2016

 clara beaudoux
@clarabdx

"My children were small when she moved in, she didn't know me, but she immediately offered to look after them"

J'AIME
5

11:29 - 11 févr. 2016

clara beaudoux
@clarabdx

In the end she never did, but she'd ask for news, and "she once gave them a Petit Larousse" illustrated dictionary

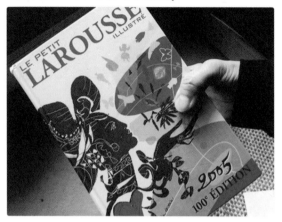

RETWEET J'AIME
1 2

11:31 - 11 févr. 2016

clara beaudoux
@clarabdx

There is also a Larousse in two volumes in the cellar, but not from the same year…
#Madeleineproject

RETWEETS J'AIME
2 4

11:32 - 11 févr. 2016

 clara beaudoux
@clarabdx

In that Larousse, the first world war doesn't exist yet #Madeleineproject

RETWEET J'AIME
1 7

11:33 - 11 févr. 2016

 clara beaudoux
@clarabdx

Let's look up the letter "E," for example, as in "Europe," how it was 100 years ago... #Madeleineproject

J'AIME
4

11:36 - 11 févr. 2016

 clara beaudoux
@clarabdx

There's no date on the Larousse but thanks to
"published under the direction of Claude Augé" I
figure it must be from 1907-1908

J'AIME
1

11:37 - 11 févr. 2016

 clara beaudoux
@clarabdx

This Larousse is nearly representative of the world
you were born into #Madeleineproject

J'AIME
2

11:39 - 11 févr. 2016

 clara beaudoux
@clarabdx

228 What else can I look up?
#Madeleineproject

J'AIME
1

11:39 - 11 févr. 2016

clara beaudoux
@clarabdx

@NLeuthereauMorL oh here we are

nénuphar ou, suiv. l'Académie, **nénufar** n. m. Genre de nymphéacées aquatiques, à larges feuilles et à fleurs jaunes ou blanches, qui croissent dans les pays chauds et tempérés.

— ENCYCL. Les nénuphars (*nymphæa*) renferment une vingtaine d'espèces des eaux douces. Le nénuphar blanc, appelé aussi *lis blanc des étangs*, étale à la surface des eaux tranquilles des étangs de larges feuilles nageantes d'un beau vert et de jolies fleurs blanches, parfois rosées; le *nénuphar blanc d'Égypte* est le lotus sacré des anciens Égyptiens; les nénuphars jaune, blanc, bleu, sont souvent employés à la décoration des bassins dans les jardins; les graines des nénuphars jaune et blanc passaient jadis pour aphrodisiaques.

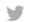
Nénuphar jaune : a, coupe de la fleur; b, fruit.

[waterlily]

RETWEETS 3 J'AIME 18

11:43 - 11 févr. 2016

clara beaudoux
@clarabdx

229

"She loved transmitting knowledge, she spoke a lot about her profession as a teacher, which she loved," continued Brigitte #Madeleineproject

RETWEETS 2 J'AIME 3

11:45 - 11 févr. 2016

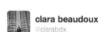 **clara beaudoux**
@clarabdx

I cannot get enough of all these little labels
#Madeleineproject

J'AIME
14

11:54 - 11 févr. 2016

 clara beaudoux
@clarabdx

Several people suggested that Madeleine
must have worked in the neighborhood, I
tried to find out where #Madeleineproject

11:55 - 11 févr. 2016

 clara beaudoux
@clarabdx

"In Paris, but not in the nice neighborhoods,
in the north-northwest, rather." "Why do you
say that?" "Because of the way she spoke."

11:55 - 11 févr. 2016

 clara beaudoux
@clarabdx

"She liked people, was a good listener, not prudish," "so I see her rather in a more working-class neighborhood" "a good woman!"

J'AIME
1

11:56 - 11 févr. 2016

 clara beaudoux
@clarabdx

"She loved children, I think she really regretted not having any of her own"
#Madeleineproject

J'AIME
3

11:56 - 11 févr. 2016

 clara beaudoux
@clarabdx

In the cellar I found a note from "a little boy who loves you a lot" to his teacher Madeleine
#Madeleineproject

RETWEET J'AIME
1 5

11:58 - 11 févr. 2016

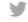

clara beaudoux
@clarabdx

In 1957, Jean-Luc wrote to Madeleine that
she was "as soft as lamb's wool" <3
#Madeleineproject

RETWEETS J'AIME
8 28

11:59 - 11 févr. 2016

clara beaudoux
@clarabdx

There are also some children's drawings in a
notebook, maybe her godson's #Madeleineproject

J'AIME
1

12:03 - 11 févr. 2016

clara beaudoux
@clarabdx

Here too some dried four leaf clovers, on blotting paper #Madeleineproject

RETWEET 1 J'AIME 4

12:05 - 11 févr. 2016

clara beaudoux
@clarabdx

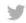

A wild herbarium, between the pages
#Madeleineproject

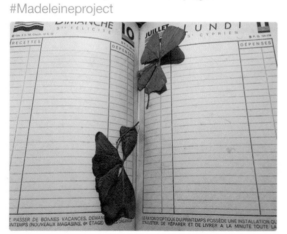

RETWEET 1 J'AIME 5

12:05 - 11 févr. 2016

234

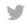

"Rain, storm, rain, first of May" #Madeleineproject

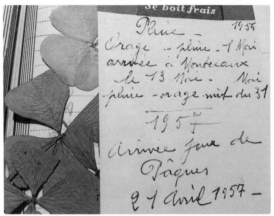

2

12:06 - 11 févr. 2016

On this page, I don't understand, were you counting every letter? Why?
#Madeleineproject

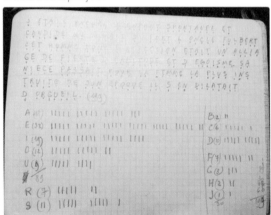

5

12:08 - 11 févr. 2016

clara beaudoux
@clarabdx

And at the end of the notebook, on tracing paper, they're frolicking #Madeleineproject

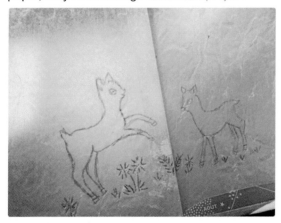

J'AIME
6

12:10 - 11 févr. 2016

clara beaudoux
@clarabdx

"She liked to laugh, have fun, she didn't take things too seriously, she was a very positive person" #Madeleineproject

J'AIME
2

12:14 - 11 févr. 2016

 clara beaudoux
@clarabdx

"I was very fond of her"
#Madeleineproject
soundcloud.com/ madeleine-proj …

 #Madeleineproject "Quelqu'un que j'aimais beaucoup" Brig...
Listen to #Madeleineproject "Quelqu'un que j'aimais beaucoup"
Brigitte by Madeleine project #np on #SoundCloud
soundcloud

J'AIME
1

12:17 - 11 févr. 2016

 clara beaudoux
@clarabdx

"Physically, she was a little woman, not very tall,
shorter than me," said Brigitte, who is 5 feet (I'm
5'1") #Madeleineproject

12:22 - 11 févr. 2016

236

 clara beaudoux
@clarabdx

"She really was plump" "She had trouble
walking, her legs would swell up"
#Madeleineproject

12:23 - 11 févr. 2016

 clara beaudoux
@clarabdx

But she went ahead and did her shopping,
apparently at the same supermarket I go to
#Madeleineproject

12:23 - 11 févr. 2016

Brigitte recalls, "yes, yes, she'd had a
husband, I think he was a teacher, too"
#Madeleineproject

J'AIME
3

12:24 - 11 févr. 2016

"At Christmas or New Year's, since I knew she
was all alone in the evening, I'd take her some little
canapés we'd made"

J'AIME
4

12:26 - 11 févr. 2016

237

"On the first of May I brought her a sprig of lily
of the valley, we got along well, there was real
fondness between us" #Madeleineproject

J'AIME
4

12:26 - 11 févr. 2016

Loneliness? "I don't think she suffered from it, she
read a great deal" "If she wasn't reading,
she would watch something on TV"

RETWEET J'AIME
1 3

12:28 - 11 févr. 2016

clara beaudoux
@clarabdx

"Don't worry, I never get bored," Madeleine
used to say #Madeleineproject

J'AIME
3

12:28 - 11 févr. 2016

clara beaudoux
@clarabdx

"She was interested in so many things, she
was outward-looking" "She always had
something lovely and exciting to tell you"

J'AIME
3

12:30 - 11 févr. 2016

clara beaudoux
@clarabdx

"She talked a lot about traveling, too" "she
loved travel books" or programs on television
#Madeleineproject

J'AIME
2

12:32 - 11 févr. 2016

clara beaudoux
@clarabdx

(Sometimes I'm a bit lost, and get the impression
the neighbors aren't just talking about Madeleine
anymore…) #Madeleineproject

12:33 - 11 févr. 2016

clara beaudoux
@clarabdx

Your travels, your memories, preserved, all mixed up, in all these photographs
#Madeleineproject

J'AIME
2

12:37 - 11 févr. 2016

DAY 4

clara beaudoux
@clarabdx

Here's Venice, I was just there in September
#Madeleineproject

J'AIME
4

12:39 - 11 févr. 2016

clara beaudoux
@clarabdx

And Egypt (I've never been) #Madeleineproject

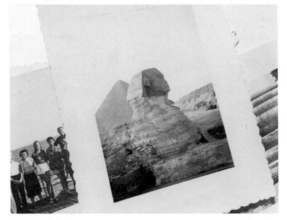

J'AIME
5

12:40 - 11 févr. 2016

clara beaudoux
@clarabdx

Could this be Greece? #Madeleineproject

J'AIME
5

12:41 - 11 févr. 2016

clara beaudoux
@clarabdx

And then Holland, of course… There's this small bag from the pharmacy #Madeleineproject

J'AIME
1

12:43 - 11 févr. 2016

clara beaudoux
@clarabdx

And various different places inside
#Madeleineproject

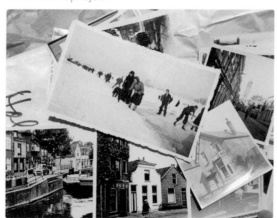

J'AIME
2

12:44 - 11 févr. 2016

clara beaudoux
@clarabdx

Are these your friends? Could that be a windmill without sails? #Madeleineproject

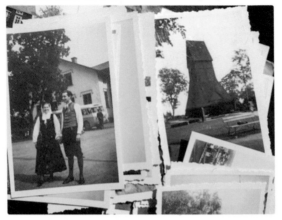

RETWEET
1

12:47 - 11 févr. 2016

242

clara beaudoux
@clarabdx

Does anyone recognize these houses? #Madeleineproject

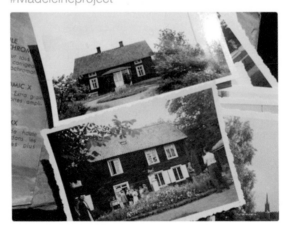

RETWEETS
5

12:48 - 11 févr. 2016

clara beaudoux
@clarabdx

And this windmill, in a notebook
#Madeleineproject

RETWEET J'AIME
1 1

12:48 - 11 févr. 2016

DAY 4

clara beaudoux
@clarabdx

Perhaps you liked Van Gogh because of Holland, too? #Madeleineproject

Extrait grat

RETWEET J'AIME
1 2

12:49 - 11 févr. 2016

clara beaudoux
@clarabdx

And where is this? #Madeleineproject

J'AIME
4

12:50 - 11 févr. 2016

clara beaudoux
@clarabdx

And this? #Madeleineproject

12:50 - 11 févr. 2016

clara beaudoux
@clarabdx

There are these lovely maps of Italy
#Madeleineproject

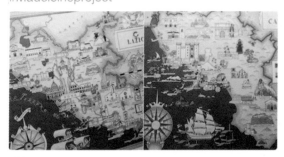

J'AIME
7

12:51 - 11 févr. 2016

clara beaudoux
@clarabdx

"In her last years, she decided to treat herself
to a month in Normandy in the summer, all
meals included, she liked the idea"

J'AIME
3

12:53 - 11 févr. 2016

clara beaudoux
@clarabdx

"She met people, played cards, and she was
always eager to go back the following year"
said Brigitte

J'AIME
1

12:54 - 11 févr. 2016

clara beaudoux
@clarabdx

This was the spa town of Bagnoles-de-l'Orne
Eveline and Robert had mentioned, and I
found a postcard in the cellar

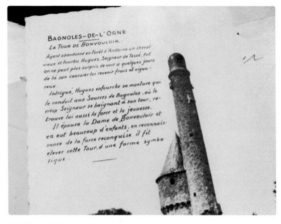

RETWEET J'AIME
1 1

12:54 - 11 févr. 2016

clara beaudoux
@clarabdx

Should I go there? #Madeleineproject

J'AIME
1

12:57 - 11 févr. 2016

clara beaudoux
@clarabdx

"At one point, if I remember correctly, she
even thought of moving there, because she
really was very happy in that place"

RETWEET
1

12:58 - 11 févr. 2016

clara beaudoux
@clarabdx

"She could go for walks along the ocean, she loved that" #Madeleineproject

RETWEET J'AIME
1 5

12:58 - 11 févr. 2016

clara beaudoux
@clarabdx

Ah yes, I could tell you loved the ocean, Madeleine #Madeleineproject

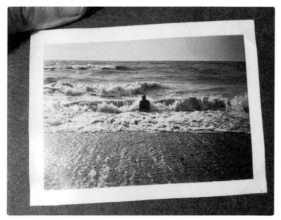

DAY 4

247

RETWEET J'AIME
1 11

13:00 - 11 févr. 2016

clara beaudoux
@clarabdx

Already as a little girl you went to the beach: "Ault 1925," you were ten years old
#Madeleineproject

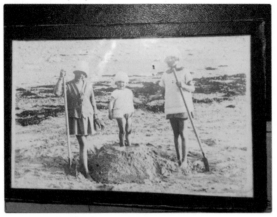

RETWEET J'AIME
1 4

13:03 - 11 févr. 2016

clara beaudoux
@clarabdx

On Tuesday Brigitte sent me an email with further details about the doorbell
#Madeleineproject

clara beaudoux @clarabdx

Cette sonnette, c'est encore ma sonnette, la voilà
#Madeleineproject soundcloud.com/madeleine-proj...

13:06 - 11 févr. 2016

[The doorbell is still my doorbell, here it is
#Madeleineproject soundcloud.com/madeleine-proj...]

clara beaudoux
@clarabdx

"So she'd know it was us, when she could still hear, we'd ring the bell three times, and only then would she open!"

RETWEET J'AIME
1 1

13:07 - 11 févr. 2016

clara beaudoux
@clarabdx

With all this I've gotten to know my neighbors, and I no longer see the old ladies in the neighborhood in the same light #Madeleineproject

J'AIME
12

13:09 - 11 févr. 2016

clara beaudoux
@clarabdx

And now when I go by a secondhand store I imagine all the lives behind every object: it makes my head spin #Madeleineproject

RETWEET J'AIME
1 18

13:09 - 11 févr. 2016

clara beaudoux
@clarabdx

249

I needed these meetings with the neighbors, they've been a source of ongoing inner sighs of relief #Madeleineproject

J'AIME
4

13:10 - 11 févr. 2016

clara beaudoux
@clarabdx

Every time I made an appointment, rang a doorbell, I was afraid I'd meet the person who would tell me to stop the #Madeleineproject

J'AIME
1

13:11 - 11 févr. 2016

clara beaudoux
@clarabdx

But then I saw their emotion, their enthusiasm – these people who knew her – and it made me want to go on, more than ever #Madeleineproject

J'AIME
10

13:16 - 11 févr. 2016

clara beaudoux
@clarabdx

I still had to meet the godson, I'll tell you about that tomorrow #Madeleineproject

J'AIME
10

13:17 - 11 févr. 2016

clara beaudoux
@clarabdx

More tomorrow #Madeleineproject
madeleineproject.fr

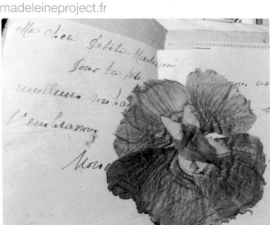

RETWEETS J'AIME
2 13

13:18 - 11 févr. 2016

SEASON 2

clara beaudoux
@clarabdx

It took me a while to dare to get in touch with
her godson again, after Season 1
#Madeleineproject

J'AIME
2

11:09 - 12 févr. 2016

clara beaudoux
@clarabdx

Finally one day I decided to call him at home.
I kept getting his wife, and dogs barking in
the background #Madeleineproject

J'AIME
2

11:11 - 12 févr. 2016

clara beaudoux
@clarabdx

Eventually I got him. He hadn't heard about my
project. But he liked the idea #Madeleineproject

J'AIME
4

11:11 - 12 févr. 2016

clara beaudoux
@clarabdx

I asked him what he thought about social
media, and he made me laugh when he said
he was "anti": #Madeleineproject

RETWEET J'AIME
1 3

11:12 - 12 févr. 2016

clara beaudoux
@clarabdx

"All these people telling their life stories on
social media, then complaining because of
cameras in the street" #Madeleineproject

RETWEETS J'AIME
4 8

11:12 - 12 févr. 2016

clara beaudoux
@clarabdx

After he'd read Season 1 he said: "it's poetic," "I even learned a few things"
#Madeleineproject

RETWEET J'AIME
1 3

11:14 - 12 févr. 2016

clara beaudoux
@clarabdx

And he was the one who suggested we meet
#Madeleineproject

J'AIME
3

11:14 - 12 févr. 2016

clara beaudoux
@clarabdx

I showed up with a list of fairly precise questions. He was able to answer them all, obviously; for him it's all so clear #Madeleineproject

J'AIME
4

11:16 - 12 févr. 2016

clara beaudoux
@clarabdx

Madeleine's parents were friends with his mother's parents, and Madeleine and his mother were very good friends #Madeleineproject

J'AIME
2

11:17 - 12 févr. 2016

clara beaudoux
@clarabdx

Madeleine never had any children, no. "I
played that role, to a degree," he said
#Madeleineproject

J'AIME
4

11:18 - 12 févr. 2016

clara beaudoux
@clarabdx

Madeleine was never married, no. But she
lived with a man for a few years, another
teacher: Bernard #Madeleineproject

J'AIME
4

11:19 - 12 févr. 2016

254

clara beaudoux
@clarabdx

And yes, as I thought, that's the Bernard who
is mentioned more than once in the cellar
#Madeleineproject

J'AIME
2

11:19 - 12 févr. 2016

SEASON 2

clara beaudoux
@clarabdx

And his signature is this lovely scribble
#Madeleineproject

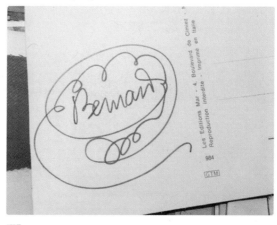

J'AIME
7

11:20 - 12 févr. 2016

clara beaudoux
@clarabdx

Here's an entire bundle of letters from him
#Madeleineproject

J'AIME
6

11:21 - 12 févr. 2016

clara beaudoux
@clarabdx

In one of them he cut off the edge of a postcard because it wouldn't fit in the envelope, I had to laugh

RETWEETS J'AIME
2 14

11:23 - 12 févr. 2016

clara beaudoux
@clarabdx

Sometimes there are little plants between the pages of his letters, he knew you liked that
#Madeleineproject

J'AIME
10

11:25 - 12 févr. 2016

 clara beaudoux
@clarabdx

Otherwise his letters are full of everyday things, of the kind I'd no longer know how to write about on paper #Madeleineproject

J'AIME
2

11:27 - 12 févr. 2016

 clara beaudoux
@clarabdx

And then there's this complicated business with his daughter, it seemed it wasn't funny at all #Madeleineproject

J'AIME
1

11:28 - 12 févr. 2016

 clara beaudoux
@clarabdx

I read things like "don't cry too long," "no sorrow, it's pointless," it sounds sad, gray, cold like the concrete around me

J'AIME
3

11:29 - 12 févr. 2016

 clara beaudoux
@clarabdx

I decided not to go into all that #Madeleineproject

J'AIME
3

11:30 - 12 févr. 2016

 clara beaudoux
@clarabdx

Madeleine's godson recalls a "superb" woman, "she was more than a godmother to me" #Madeleineproject

J'AIME
4

11:31 - 12 févr. 2016

 clara beaudoux
@clarabdx

They were "very close," he spent "his entire youth" with her, "her parents were wonderful people" #Madeleineproject

J'AIME
1

11:31 - 12 févr. 2016

 clara beaudoux
@clarabdx

In Bourges, Madeleine's mother had a shop, a haberdashery #Madeleineproject

RETWEETS J'AIME
2 3

11:32 - 12 févr. 2016

 clara beaudoux
@clarabdx

Now I see this little bag I found in the cellar
in a new light #Madeleineproject

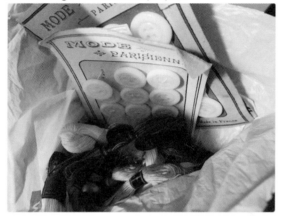

J'AIME
4

11:33 - 12 févr. 2016

DAY 5

259

clara beaudoux ·
@clarabdx

I emptied it out into one of your many
boxes, there were all kinds of buttons
#Madeleineproject

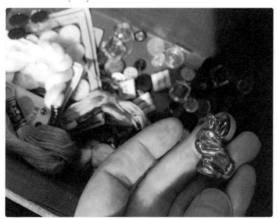

J'AIME
2

11:36 - 12 févr. 2016

clara beaudoux
@clarabdx

And this, too, looks like supplies from a
haberdashery, don't you think? #Madeleineproject

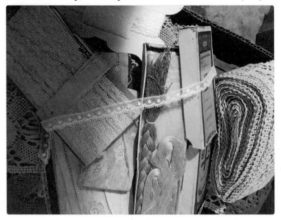

RETWEET J'AIME
1 6

11:37 - 12 févr. 2016

clara beaudoux
@clarabdx

Her godson went on: Madeleine's father
had been a teacher in a technical school
#Madeleineproject

11:38 - 12 févr. 2016

clara beaudoux
@clarabdx

So these compasses must have been
your father's #Madeleineproject

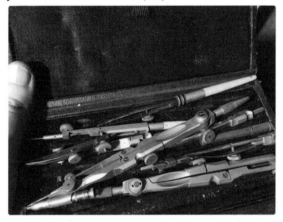

J'AIME
2

11:40 - 12 févr. 2016

clara beaudoux
@clarabdx

And all these little technical drawings that
I found in one of your father's datebooks
#Madeleineproject

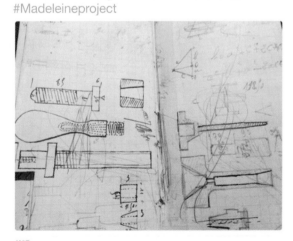

J'AIME
2

11:41 - 12 févr. 2016

clara beaudoux
@clarabdx

Madeleine came to Paris as a very small child, she'd always lived in this quartier, in my quartier #Madeleineproject

RETWEETS
2

11:42 - 12 févr. 2016

clara beaudoux
@clarabdx

In the summer, yes, she went on her own to Normandy, she was an "extremely independent woman," said her godson #Madeleineproject

RETWEETS J'AIME
4 3

11:43 - 12 févr. 2016

clara beaudoux
@clarabdx

What did she like? "Everything." "She read a lot," "she was interested in everything, even at the end of her life" #Madeleineproject

RETWEETS J'AIME
3 3

11:45 - 12 févr. 2016

clara beaudoux
@clarabdx

Madeleine told him, "What I really regret is that I won't live long enough to learn about everything I want to explore"

RETWEETS J'AIME
10 6

11:46 - 12 févr. 2016

 clara beaudoux
@clarabdx

"She was interested in the most incredible things, however modern, I wouldn't go so far as to call her a geek, but…" #Madeleineproject

RETWEETS J'AIME
2 5

11:48 - 12 févr. 2016

 clara beaudoux
@clarabdx

She also had a "prodigious memory," said her godson, she remembered everything she read #Madeleineproject

RETWEETS J'AIME
2 3

11:49 - 12 févr. 2016

DAY 5

clara beaudoux
@clarabdx

263

All the same "she had a foul temper," he added, "she couldn't stand being contradicted, but the worst of it was that she was often right"

RETWEETS J'AIME
3 5

11:50 - 12 févr. 2016

clara beaudoux
@clarabdx

With your godson we drew another diagram of my/
your apartment #Madeleineproject

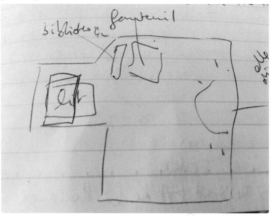

J'AIME
2

11:54 - 12 févr. 2016

clara beaudoux
@clarabdx

Her bed was indeed in the same place as mine, but
turned the other way! How funny, I've been wanting
to try that out for a while now…

J'AIME
2

11:55 - 12 févr. 2016

clara beaudoux
@clarabdx

And so where did she teach, for the most part?
#Madeleineproject

RETWEET J'AIME
1 1

11:56 - 12 févr. 2016

clara beaudoux
@clarabdx

Rue Championnet in the 18th arrondissement, said the godson, "that's where she spent her entire working life" #Madeleineproject

RETWEET 1 J'AIME 9

11:57 - 12 févr. 2016

clara beaudoux
@clarabdx

So I went to see the school
#Madeleineproject

DAY 5

RETWEET 1 J'AIME 4

11:59 - 12 févr. 2016

clara beaudoux
@clarabdx

And I thought that the sound of children in the playground wouldn't have changed much from her days #Madeleineproject

J'AIME 1

12:00 - 12 févr. 2016

clara beaudoux
@clarabdx

Madeleine also taught in Aubervilliers, I found class photos in the cellar twitter.com/clarabdx/statu … #Madeleineproject

clara beaudoux @clarabdx

Dans une valise, plein de photos de groupes ou de classes avec une personne en commun sur chaque.. #Madeleineproject

J'AIME
3

12:01 - 12 févr. 2016

[One suitcase full of photographs of groups or classes, the same person in each of them.
#Madeleineproject]

clara beaudoux
@clarabdx

I had the opportunity to walk around the school, I hope to tell you about it soon #Madeleineproject

J'AIME
3

12:02 - 12 févr. 2016

clara beaudoux
@clarabdx

What was so important about Montceaux-lès-Meaux, which I found mentioned so often in the cellar? #Madeleineproject

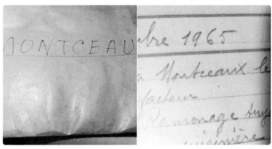

J'AIME
3

12:04 - 12 févr. 2016

clara beaudoux
@clarabdx

It was her parents' country house; her godson made me a map so I could find the house #Madeleineproject

J'AIME
1

12:06 - 12 févr. 2016

clara beaudoux
@clarabdx

Should I go there? #Madeleineproject

J'AIME
5

12:06 - 12 févr. 2016

 clara beaudoux
@clarabdx

A little further along on the map he drew a
rectangle: this was Madeleine's father's
orchard, there were apples to make cider

12:08 - 12 févr. 2016

 clara beaudoux
@clarabdx

I think I saw that orchard, all the way from
the cellar #Madeleineproject

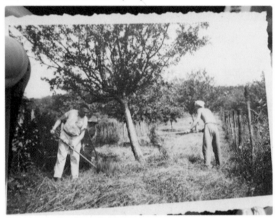

J'AIME
4

12:10 - 12 févr. 2016

 clara beaudoux
@clarabdx

Her godson also remembered Madeleine's
mother's cooking in Montceaux, "even today,
an aroma can take me right back there…"

J'AIME
4

12:11 - 12 févr. 2016

 clara beaudoux
@clarabdx

A bit like Proust's madeleine…
#Madeleineproject

J'AIME
4

12:12 - 12 févr. 2016

 clara beaudoux
@clarabdx

Here you are the three of you, outside the house in Montceaux in 1947… #Madeleineproject

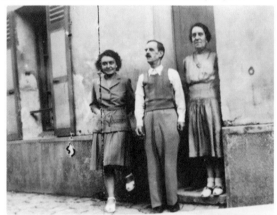

J'AIME
7

12:17 - 12 févr. 2016

clara beaudoux
@clarabdx

Here it's harvest time, somewhere near there, too, I think #Madeleineproject

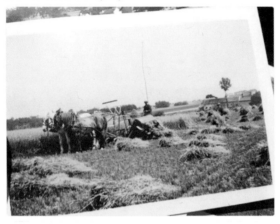

RETWEET 1 J'AIME 2

12:17 - 12 févr. 2016

clara beaudoux
@clarabdx

I've decided to go to Montceaux anyway, since the place is part of Loulou's story #Madeleineproject

J'AIME 7

12:19 - 12 févr. 2016

clara beaudoux
@clarabdx

I'd been looking everywhere for Loulou in your photographs, again and again #Madeleineproject

12:20 - 12 févr. 2016

 clara beaudoux
@clarabdx

Until I found a handsome young man
#Madeleineproject

J'AIME
2

12:22 - 12 févr. 2016

 clara beaudoux
@clarabdx

The dates might match, but unfortunately
you never indicate who is in the photo
#Madeleineproject

J'AIME
1

12:22 - 12 févr. 2016

clara beaudoux
@clarabdx

There's an entire series of photographs of
him #Madeleineproject

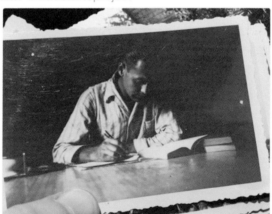

RETWEET J'AIME
1 10

12:23 - 12 févr. 2016

And I start imagining the love you felt, behind the camera lens #Madeleineproject

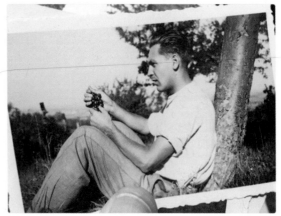

RETWEETS J'AIME
2 16

12:24 - 12 févr. 2016

clara beaudoux
@clarabdx

There are a few photos of the two of you as well. But is it really him? How would I know? #Madeleineproject

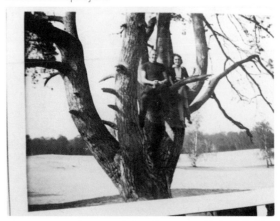

J'AIME
7

12:25 - 12 févr. 2016

clara beaudoux
@clarabdx

Your passion for four-leaf clovers: I found this little piece of paper, folded and glued, but I can see through it

12:29 - 12 févr. 2016

clara beaudoux
@clarabdx

And inside, yes, there's a little four-leaf clover, you've kept it safe #Madeleineproject

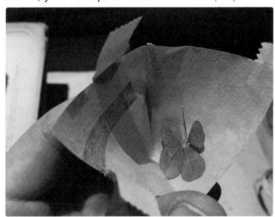

12:30 - 12 févr. 2016

clara beaudoux
@clarabdx

There's also this tiny paper bag
#Madeleineproject

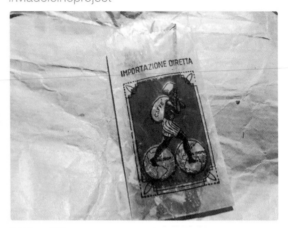

RETWEET J'AIME
1 3

12:31 - 12 févr. 2016

clara beaudoux
@clarabdx

Inside, as always, there's a useless little
treasure, and I touch it with my fingertips,
not to damage it #Madeleineproject

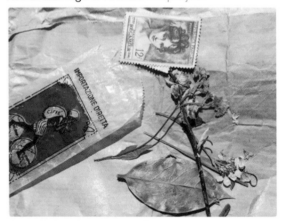

RETWEETS J'AIME
2 15

12:31 - 12 févr. 2016

 clara beaudoux
@clarabdx

So fragile, and yet it has come through time
#Madeleineproject

RETWEETS J'AIME
3 9

12:33 - 12 févr. 2016

 clara beaudoux
@clarabdx

And I put it all back as it was, as carefully as I can.
As if you might come back to get everything…
#Madeleineproject

RETWEET J'AIME
1 7

12:34 - 12 févr. 2016

 clara beaudoux
@clarabdx

Her godson remembers Madeleine's good
Dutch friends, they had been "pen pals" with
her and her parents #Madeleineproject

J'AIME
1

12:37 - 12 févr. 2016

 clara beaudoux
@clarabdx

He told me that they are dead, but they had five children. The cellar is full of them, too #Madeleineproject

12:38 - 12 févr. 2016

 clara beaudoux
@clarabdx

Her godson went to Holland with her once #Madeleineproject

12:39 - 12 févr. 2016

 clara beaudoux
@clarabdx

Should I go there, too? #Madeleineproject

J'AIME
4

12:40 - 12 févr. 2016

clara beaudoux
@clarabdx

And in this photograph, aren't you
wearing a traditional Dutch costume?
#Madeleineproject

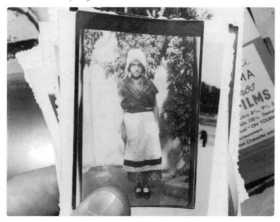

J'AIME
4

12:43 - 12 févr. 2016

clara beaudoux
@clarabdx

The sea, which you so loved, to take us
closer to the end #Madeleineproject

RETWEETS J'AIME
4 14

12:48 - 12 févr. 2016

 clara beaudoux
@clarabdx

Madeleine died in the hospital, "not exactly a
serene death, so to speak" #Madeleineproject

J'AIME
1

12:49 - 12 févr. 2016

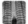 **clara beaudoux**
@clarabdx

She was cremated, as she'd asked, and
her ashes were scattered in Bourges
#Madeleineproject

RETWEET J'AIME
1 5

12:50 - 12 févr. 2016

 clara beaudoux
@clarabdx

I worry over the fact there is nothing, no plaque
in a cemetery. "She wasn't at all religious, you
know," "like a lot of teachers."#Madeleineproject

RETWEET J'AIME
1 5

12:51 - 12 févr. 2016

 clara beaudoux
@clarabdx

To me it's as if she'd suddenly disappeared,
so there's nowhere I can go and see her one
last time #Madeleineproject

RETWEET J'AIME
1 2

12:52 - 12 févr. 2016

clara beaudoux
@clarabdx

And I've received so many answers just now, all at once #Madeleineproject

RETWEET 1 J'AIME 2

12:53 - 12 févr. 2016

clara beaudoux
@clarabdx

I wanted to emerge from the magic of that cellar by picking up my journalist's tools and going to interview the living #Madeleineproject

RETWEETS 2 J'AIME 6

12:54 - 12 févr. 2016

clara beaudoux
@clarabdx

DAY 5

But I feel a bit stunned by so much reality #Madeleineproject

279

J'AIME 3

12:54 - 12 févr. 2016

 clara beaudoux
@clarabdx

So I go back down into the basement
#Madeleineproject

RETWEET J'AIME
1 3

12:55 - 12 févr. 2016

 clara beaudoux
@clarabdx

And open the box full of stickers of stars, and I
picture you gluing them #Madeleineproject

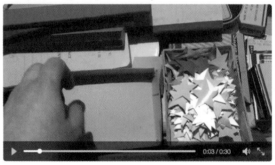

0:03 / 0:30

RETWEETS J'AIME
2 5

12:58 - 12 févr. 2016

280

SEASON 2

 clara beaudoux
@clarabdx

And I go back to my persistent, insoluble
questions, the ones that set me endlessly
dreaming. With some of them I've made some
progress

RETWEET
1

12:59 - 12 févr. 2016

clara beaudoux
@clarabdx

What, for you, was beautiful? Where did your imagination wander? What did you dream about? What was your voice like?
#Madeleineproject

RETWEET J'AIME
1 4

13:00 - 12 févr. 2016

clara beaudoux
@clarabdx

What did you desire? What made you joyful, angry? What were your beliefs? What was your inner landscape like? #Madeleineproject

RETWEETS J'AIME
2 4

13:00 - 12 févr. 2016

 DAY 5

clara beaudoux
@clarabdx
281

What would you have thought of all this?
#Madeleineproject

RETWEETS J'AIME
2 9

13:00 - 12 févr. 2016

clara beaudoux
@clarabdx

~ To Madeleine ~

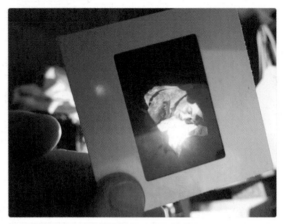

Many people responded to the tweets published in this book. The initial idea was to print all their responses on paper, but in the end there were just too many!

And so for all of this, your comments, remarks, questions, suggestions, ideas, theories, and your support, many thanks:

@__Styx__ @_olivier_m @16ames @1GRR @54Lilly @A2na_Gautier @Aire_Azul @AKrempf @alablo @Alb_B @aldelafontaine @alffds @aliciapleure @alixadi @Ann_BLAblabla @annatwit @Anne_JM @annelaurechouin @annelisebth @annepins @AnneSoC85 @AntoineMR @AntoSavey @apenche @apinczon @ArMelleP @Aschving @ASignoret @AtelierEditions @AteliersVaran @aureliecolorbd @AurianeHamon @auroredeferry @avdbeken @AydenSheridan @B_Maxibear @Bablefo @bapschweitzer @BazardesReves @Belgioscopie @BenHimself75 @bensedira23 @BereniceVIGROUX @bertrand_caza @Bexounet @BHartrig @BleuAzur_ @blogHomeCollect @BMDijonPat @BobbyFreckles @Bossancourt @boumla @BoutS_de_Moi @BPromerat @bregeon_lucas @c_Tribz @cajgana @Caloute47 @CamilleBrinet @CaroBindel @carolinecaldier @CatherineMethon @cathpn @cbdhugo @ce_cile @CecileGuthleben @Celine_COUROUX @celinebras @Cetetelle @CharlotteZipper @chaussademadele @Chipeste @christeljeanne2 @Cinema33Annie @clairdevil @ClaudieMousnier @cm2aJeanMace @colinecordonni1 @Comme_un_orme @CoralieMensa @CordeliaBonal @couleurkf @couleurlivre @CourretB @cyberal77 @dalva7513 @DamidotValerie @damienblogue @danieldusud @dankstphoto @dapickboy @DeboHas @Deedo_75 @delateuranonyme @delphOsmont @denissouilla @des_milkynut @DidierDN @difference134 @DimScapolan @DiogenedArc @dobarba @Doespirito @dolu51 @donjuan_dvro @DoretGaelle @drejulie @DrTocToc @E_Chatelais @EleonoreDMA @elianecaillou @elikxir @ellewildi @emalquier @Emilier1CH @estelle_cognacq @exsonvaldes @F4FXL @fleche72 @FloGeneuf @FranckSerein @frapuchon @FredDaurelle @Freddinette @fredehl @fredhaffner @Frenchwithfun @FRousselot @fuchsadele @fxverdot @GaelleFontenit @GeChamussy @germainebertin @GI581d @GLiberge @gnujeremie @GossiplyYours @guepier92 @GwenPaine @HerveMarchon @i_car @ilesttropgentil @IraJaymes @Iris_Oho @Ivy_Pearson @jchrimartin @JcWasner @jeffsimmarano @jerome_autour @JeromeTomasini @joaquim_hock @judith_rueff @Jujuuz_ @julien_goy @JulieNavarro @juliengoetz @julienmuguet @JulieSeniura @JWullus @KanorUbu @KareneBellina @katia67951530 @KatKitten4 @kenny33600 @khhiii @KoliaDelesalle @Krakramille @krislesage @ktorz @l_anelli @L3naWho @LaBombeH @lachtitebibou @Lagouelle @LanaM90 @Laroche1Claude @LaureBeaulieu @laurencegeny @LauryPouvreau @LC_Agathe @Le_Bip @Le_P AH @lea_robine @leAmato13 @leberry_fr @leblognoteur @lecamifat @Lefevregaessler @LepouseX @leroylaurent @liane_belo @liaskerrit @lilibotte @limonadeandco @LionelFrancou @Lipovitca @LLI66 @lolawichegrod @lryngael @LStrapontine @LulamaeA @LumentoFilm @M_Mondoloni @MagalivonWurm @MagnaMatrona @malachy1009 @ManuGavard @manujar @Maraud_Whisky @Marcfauvelle @mariambourgeois @marie_samuel54 @marie_simon @mariebernardeau @marielandro @MarieLaureC @MarineProt @marion_mvl @marion_seury @marionbee @Marj089 @marsupilamima @martoche @Mast3rMan

@mathauger @mathildedehimi @MathildeL75 @mattbeauv @MattGuenoux
@Mauddk @mcledu @MEEFista @Meguini @MelleJeanne @MerletteNoname
@Mhe_sch @midatlantic61 @MidouBb2 @miickyid @minisushi @mirayoki
@MissCocoBoca @MissCorail @MissTerre33 @MistaNiiko @mnclem
@mondeenderoute @monsieurkaplan @morokhon @Mrlanou @n___f @NassiraELM
@nathcauville @nbirchem @NCPnantes @NGouerec @nico_teillard @Nicoleduforum
@NicoLepige @NinaProvence @nivrae @NLeuthereauMorL @nolwennbb
@noukapi @objectifocean @OFavennec @OlivierBenis @Padre_Pio @parisbiarritz
@parleluidemoi @Pascal_Le_Mee @pascal201169 @PaulineCallois @PaulineMiel
@pcolinleroux @PetitDeux @petitdonnet @PhilippeLoizon @pierrebrt @pierrecouette
@pippojawor @PopEnnio @potop @PoulyO @qdeslandres @Quand__Meme
@Radioteuse @RemDumDum @renardtouffu @RienaFoot777 @RiveMerry
@rizzonefer @RodolpheCaribou @ronez @rosepiter @SanzzoCreatrice @SarahBastien
@SaskiaVanMachin @sca421 @Sceptie @Scharlottelazimi @SChesnel @SebCalvet
@SebGaff @semioblog @serrantho @Simonemonpote @sistermiam @sletellier21
@somebaudy @sophie31770 @sophiegiron @spoum42 @Stars_buck @Stbslam
@stefandevries @Stefany_cm_h @stefgossip @SundaaayMorning @supergreg3
@Syluban @taimaz @tangente86 @tellinestory @temptoetiam @thbaumg
@The_Funny_Bird @Thomas_Chuette @Thomrichet @thomrozec @TierceMajeure
@tigoulinade @Til1988 @Timithil @tofer_dreamer @Tomasin9 @tomland
@Toussaintcat @tristan_m @tristanmf @trukmus @TUMinterS @turlupinRF
@tylemeray @unGwennEnHiver @urbanbike @vagabondanse @Val__Tho @Val69110
@ValdvLyly @ValerieAMaitre @VictoireHM @Vince_von_Stgt @VinceBlackdog
@vincentguerin @vprly @Watbibi @Watoo_Watoo @wilddust @XavierPauf
@XavierReim @Ximena_69 @YannBertrand
@YvetteIvresse @zigazou @Zollkau

Thanks to all those who posted comments on Facebook, too.
For your precious help, thanks to Geneviève, Étienne, Simon, Carole,
Léonard, and all my friends <3

For your trust, thank you Brigitte, Marc, Sylvain, Eveline,
Robert, and very special thanks to Madeleine's godson.

For this journey onto paper, so precisely, thank you Adrien,
thank you Claire.

Thank you chance, fate, and magic.

Thank you,
Madeleine.